THE NEW
WORLDS OF WOMEN

THE
NEW
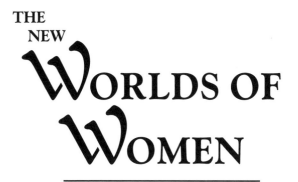
WORLDS OF
WOMEN

Expanded Edition

edited by Cecilia Tan

Circlet Press, Inc.
Cambridge, MA

The New Worlds of Women, expanded edition

Circlet Press, Inc.
1770 Massachusetts Avenue, #278
Cambridge, MA 02140
http://www.circlet.com/circlet/home.html
circlet-info@circlet.com

Typeset and printed in the United States of America.

ISBN 1-885865-15-5 (previous edition 0-9633970-6-0)

First printing: June 1996

An earlier version of "Why the Sea Is Salty" by Kitty Tsui appeared
in *Common Lives, Lesbian Lives* and *Hear the Silence: Stories by
Women of Myth, Magic and Renewal.*

Retail, wholesale, and bulk discounts are available direct from
Circlet, or from the fine wholesalers who carry our complete line of
books, including Alamo Square Distributors, AK Distributors,
Bookazine, Bookpeople, Koen Book Distributors, and Last Gasp of
San Francisco. In the United Kingdom and Europe, Circlet Press is
represented by Turnaround Ltd., London.

Contents

Introduction

If this is the first time you have ever seen the book *Worlds of Women,* published by Circlet Press, you may wonder at the "new, expanded" appellation it bears on the cover. The original edition of *Worlds of Women* appeared in 1993, when Circlet was a much smaller company, when our "mission" of creating the new subgenre of literature we call erotic science fiction was new. The print run was small, our distribution was small, our reputation was small. The promotion budget for the book consisted of enough money to mail out about ten review copies and take out one ad in Feminist Bookstore News. It was also a small book, five short stories bound into a paperback so slim it is hard to see on a shelf.

Which isn't to say the book went unnoticed. *Feminist Bookstore News* reviewed it. One of the stories in it, "None of the Above" by Bernadette Lynn Bosky, was chosen for inclusion in the 1994 *Best American Erotica* by Susie Bright. And suddenly it looked as if erotic science fiction might catch on.

The best of any fiction shows us something about reality, about life and being human. The best of science fiction (or fantasy or speculative fiction or whatever you may call it) does the same thing, but through the specific lens of imaginings beyond our real world. Any subject can be explored: politics, commerce, ethics, families, the author's emotions, pet peeves, traumas, and self. With erotic science fiction the subject of that imaginative speculation is sex, and in the full

meaning of the word erotic, is good, healthy, arousing, fulfilling sex. With *Worlds of Women* I specifically wanted stories that used the lens of science fiction to explore what it is to be a woman who loves women. Those first five stories were a start. Now it is 1996, and Circlet Press is growing, our books are growing in size and so are our print runs. I realized as I began to collect new manuscripts this year that those five stories deserved to be kept in print and to reach new readers. So here we have the new, expanded edition of *Worlds of Women,* with the original five stories intact, and six new tales envisioning erotic worlds among women. Lesbian secret agents, dragon women, woman-loving goddesses come to life, telepathic women awakening their sexuality, parthenogenetic women, and body-morphing women who challenge the meaning of their biological gender all inhabit these sexy, celebratory stories. Come join them.

<div style="text-align:center">

Cecilia Tan
Editor/Publisher

</div>

Linda Hooper

The Annunciation

All through those tumultuous first months, in spite of the conversations going into the night, the endless speculations and terrifying mood swings, there was one thing she told no one.

It was so private—it felt private to her. It happened when she was almost asleep. She was honest with herself; she knew it wasn't a dream and couldn't pretend it was. But the reality of it sometimes made her wish it was a dream.

The first time had been just a few months earlier. She had read a magazine for a while, and switched off the light, pretending that her despondency was really fatigue. She lay there, missing Tess, missing Tess's touch, missing the habit of Tess touching her. She lay there for a long while before realizing she was tired, but too alone to sleep.

I wish I had a lover again, she realized. She thought about moving her hand to her cunt, maybe coming would help her to sleep. She tried to think of a fantasy erotic enough to interest her and her despair deepened.

She was lying on her side, near the edge of the bed unmoved in the dark. She imagined the touch of a woman's body spooned into hers, and then, suddenly, there almost

was. Far less than real, but more solid than thought. Mary no longer felt alone.

She thought it wraithlike, a wisp of life energy, forming around her. This woman—it was somehow a woman, the very essence of woman—wanted her. This spirit wanted Mary to be excited, to rise in pleasure, to cry out like a woman on the edge of conscious happiness.

The woman slipped her hand under Mary's arm and cupped her breast, rolling the nipple. Mary reached up to stroke the hand, and touched her own nipple instead. She never before had felt much pleasure touching her own nipples, but now it was all she wanted to do. Two sets of fingers on her right nipple, rolling, kneading, pinching. She felt it right down to her cunt, somewhere between her cervix and vulva.

The woman seemed to know this, and pushed her hips harder into Mary's ass. Their legs intertwined, the woman rubbed the tops of Mary's feet with her own as she moved her hand away from Mary's nipple, down her belly to her pubic hair.

She slipped an arm under Mary's body and held her tight, in a two-arm embrace that would have been uncomfortable if not impossible for a solidified woman. Mary heard herself moan, and the woman nuzzled her neck, kissing the edge of Mary's ear. The woman loved what Mary was feeling. She knew how good it felt to be together, flesh and spirit like this. The woman had only one thought, one desire at this moment—to love Mary as women love—souls, thoughts, skin, heat.

The woman pressed Mary's cunt with her open hand and Mary again followed the hand and touched herself. Mary opened her mouth and the woman kissed it, again thrilling Mary in an impossible caress. The woman held breasts, nipples, throat, somehow with the fingers of one hand, and

pressed through Mary's belly with the palm and fingers of the other, just above the pubic bone. As Mary's fingers ran back and forth along her clit, the woman rubbed Mary's clit from beneath, inside. With a thought, the woman rolled atop Mary, and Mary lay on her back and together they rocked, the woman half inside, half on top of Mary's body, her mouth and tongue deeper into Mary's mouth than she had ever been kissed.

They rocked together until Mary came, and then with her last gasps and moans she laughed. "Let's do it again," she said out loud.

Reneé M. Charles

Genus Olisbos

"**D**on't worry, it won't bite, just ... tickle a little," Amir teased as she lowered the firm, yet oddly pliant artifact closer to my spread-open labia. But even though I was tied by wrist and ankle to the four low-jutting posts of our bed, not really able to move that much, I still ground my bottom deeper into the spongy air-filled mattress as I murmured, "I don't know about this ... do you really know what it is? Aren't you just guessing what it's for?"

Amir leaned close to my face, so that her swinging sheaf of shiny black hair brushed against my already-stiffened nipples, and said, "We already know that the people on the planet were quite humanoid. Their paintings and sculpture bear witness to that fact, as do the burial digs. As in, insert knob A into slit B ... and these things were found in the bedchamber of a woman. A most self-sufficient lady, from the looks of her toys." For emphasis, Amir reached over to the low bedside table and picked up each of the other artifacts in turn, showing them to me in all their bizarre, yet alluring detail:

The two-pronged spongy shaft with the generous ribbing and knoblike protuberances along its length.

A concave contact-lens-shaped floppy thing with irregular nubs and feathery-fine filaments dotting its inner surface. That hefty twin-balls-mashed-together device, with the trailing spray of filaments culminating in dozens of asterisk-like spiny balls.

And, that jelly-soft, simultaneously rigid contrivance which reminded me of the famed "Cantonese groin" I'd read about in erotic Chinese literature: the sprouting phallus-shaped plant which, when soaked with liquid, then allowed to dry, formed a natural dildo.

If all these things were what Amir thought they were, that alien woman certainly did have her sexual needs ... shall I say, well in hand, but the potential for unknown and unimaginable pleasure was dampened by my unanswered concerns.

"But what if you weren't able to sterilize them? I mean, do you really know what they're made of?" As I spoke, I could feel the intense sticky warmth lubricating my vagina and inner labia. I squirmed against the slippery-smooth bottom sheet of our bed, my spread-eagled limbs making little rubbing noises on the taut fabric below.

Amir shifted from her squatting position on her calves to a kneeling pose next to the bed, her breasts level with the top of the mattress. Her tightly puckered nipples brushed against my left thigh as she replied, "Yes, my pet. We were able to sterilize them. As far as we can tell, they're a form of rubber or latex. Not porous enough to harbor germs or bacteria. One of the other members of the dig dissected one, and it's quite solid through and through. She didn't find anything in the samples she analyzed, either." Amir went on describing the reasons it was safe as she once again used the pale greenish length of alien whatever to brush aside the short-trimmed hair on my mons, before nudging the gently rounded tip ever closer to my waiting labia and throbbing

clit. But once more, I tried to shift away from the artifact's unknown caress, the low bedposts groaning in protest as I wiggled about on the bed.

If only it wasn't my turn in our set of velvet-cuffed ropes, if only I was the dominant partner that evening...

But Amir was enjoying her turn as initiator tonight, the same night she'd brought home a sampling of artifacts so recently discovered on that as-yet-unnamed planet she and her fellow exo-anthropologists had been studying. And, of course, she had chosen to wait until after I was securely pinioned before bringing out her little surprise and displaying her treasures on our bedside table.

Getting to her feet, she padded over to the light-dimmer, and dialed down the lights a touch, just enough to cast a more golden illumination on the waiting assortment of alien "toys" she'd secreted in her many-pocketed lab jacket before leaving the warehouse where her team stored and studied the offworld treasures.

Still standing by the dimmer panel, Amir assured me, "I wouldn't have brought them for us to use if I didn't think them safe. You know I'd never hurt you, with or without safewords. I just thought you'd enjoy them. That we'd enjoy them."

Arching my pelvis up as I spoke, to try and relieve the building ache in my throbbing labia and jutting clit (the sensation of the room's cool air hitting the warm, moist flesh was almost unbearably yet exquisitely painful), I half moaned, "I'd feel better if you tried one first. You're not tied down, in case something went wrong."

Amir's slightly upturned breasts jiggled as she hurried over to the table, then picked up the twin-horned ribbed-and-knobbed artifact, and asked, "Would this do?"

Realizing that she'd bested me by picking the only dual-action toy on the table, but feeling too pent-up and horny to

debate the matter, I squirmed in place while nodding my assent ... then had to wait in pelvis-writhing anticipation while Amir picked up a tube of almonds-and-honey-scented lubricant and squirted a generous dollop into her palm. The dim light cast a deep, glinting illumination on the mound of creamy-white lotion in her cupped hand. She squatted in place and opened her thighs wide enough to part her close-clipped labia and inner lips, dipped two fingers of her other hand into the lubricant, and circled her white-tipped fingers in and around her slit ... then, using the same two fingers, she scooped up the remaining heady-scented cream and slathered it onto my waiting mons, in lazy figure eights which just managed to avoid my unhooded clit, even as she probed deep in my vagina, mingling the lotion with my own free-flowing juices.

"This thing might not be quite pliant enough," she said, before rubbing her slick hands onto the bumpy surface of the two-limbed toy, soft squelching noises as they moved across the oddly-studded surface ... but once the twin shafts were sufficiently oiled, they did begin to look less alien, and more inviting—

—and as I watched her gently but firmly shove one prong of the device into her small-lipped orifice, thrusting it up within her inch by inch, until all that was visible was the waiting half of the toy which jutted out at an inviting angle from her cleft mons, I obediently raised my pelvis, awaiting her approach.

Kneeling between my legs, Amir teased my supine torso, running her almonds-and-honey palms along my breasts over and around my slightly convex belly, then down along my hips, before encircling my waiting labia with her hands, and then—beginning with the lowest end of my labia, where it met the vagina—began massaging my inner and outer lips with her circling thumbs, increasing the pressure incremen-

16

tally as she neared my small but jutting clit. Then, still avoiding contact with my aching bud of flesh, she used one hand to guide the tip of the alien dildo across and along my moisture-sheened labia, until she reached my gaping vagina, and began to push the pliant length of rippled material into my waiting inner depths.

And although I'd been with men (while still preferring women), I'd never felt any sensation quite like this—not even when Amir had used her French-tickler-covered vibrator on me. The close-by warmth radiating from Amir's belly and thighs couldn't account for the inner all-devouring fire I felt within me: a rippling, pulsing warmth that surged and ebbed with each thrust of Amir's hips and each soft gruntlike breath she took, an almost live glow of radiating warmth and increasing intensity, an ever-changing stimulation of my own inner ribbing and outer soft folds, as if the position of the thing's knobs and ridges was changing, ever shifting for my increased pleasure—

—and judging from Amir's increasing jerkiness of motion and more frequent moans, the end of the device hidden within her was giving her equal pleasure.

Almost as soon as I wished for it, the turgid-warm device obligingly rubbed directly against my clit, until the intensity of the pleasure blotted out all other stimuli. Never before had I felt such a sense of sexual syncopation: every tactile need was met upon the instant I was aware of that need, and the wider I opened myself to its thrusting power, the deeper the device squirmed within me, seemingly growing more pliant and elongated within me, until I could almost imagine that it was brushing against the hardness of my cervix. Before the last of the orgasm-upon-orgasm burned itself out within me, the final rippling, lapping pulsations ebbing out and away from my sated labia and clit, I felt a last sensation of warm calm pass through me, and I came to my former senses on

a sheet slippery with a musky-heady mixture of almonds, honey, and my own juices.

When Amir withdrew from me, I felt the pleasure points on the device grow smaller, contracting on themselves, even as I felt a strange sense of longing for their return. And Amir's face wore an unreadable expression—not quite pleasure, not quite pain: more like longing, too.

From my prone position, I watched her pull the device out from between her labia with a soft smacking sound, then run a finger tip along the shaft. She let out a low whistle of amazement.

"I think ... I think this might be alive," she whispered, more to herself than to me, before very tenderly resting it on the table beside our bed.

Straining against my low-napped bonds, I asked her, "Did you feel it change within you, too? Almost as if it was ... reading our minds?"

"Not so much our minds, my precious. I think it read our bodies, reacting to our every reflex," Amir went on, in that same dazed tone of voice. She padded over to the bed to release me.

As she helped me to my feet, I leaned over to get a clearer look at the toys. Their pale shade of greenish white reminded me of the carved jade cock ring one man I'd known had owned, and as my eyes lingered over the enticing contours of the bulky Siamese-ben-wah-balls-like contraption for a few longing seconds, I saw them jerk slightly in place.

"I saw that," Amir said as she scooped up the device, whose feathery tail of comet-trail-fine filaments now began to writhe ever so slightly, moving in time with the beating of her heart (which made the flesh over her left breast jerk in time with each excited beat).

"Do you suppose it can sense us? Or realizes we're both so aroused?" I wondered aloud.

Amir cupped both hands around the joined rubbery spheres and lifted it off the table. Once it was free of the hard surface, the trailing tail wound itself around her wrist, bringing a groan of ecstasy from her blood-suffused lips. "Help me insert it," she whispered through trembling lips. She sat down on the edge of the bed and parted her taut thighs.

I inserted my right thumb and forefinger into her slightly gaping labia, widening the flesh until I could see the deep pink edges of her vagina, then guided her device-bearing hand close to the opening there. The joined balls obediently rolled off her palm and surged into her waiting orifice, leaving only the spray of star-tipped filaments outside her body. They began to caress and tease her labia and upper mons, writhing in and through her neatly trimmed curls, while Amir arched herself backwards, her shoulders almost touching the sheet and panting moans escaping her lips.

Realizing that she needed no further help from me, I reached behind me, feeling along the table for the dingle-dildo-like device with which she had initially teased me that evening. When my fingers made contact with that wiggling gelid surface, it immediately became warm, almost fluid under my touch.

Sitting down on the table, I picked up the bulbous and elongated artifact, and pictured it growing semitranslucent, like a balloon filled with the most luxurious, soothing emollients. When the change happened, I almost dropped the thing—it became so pliant and soft so quickly, its shape was nearly as fluid as its unseen contents. Once I had it firmly in hand, I rested its body-warm length between my breasts, luxuriating in the pulsing, quivering sensation of its liquid interior roiling against my flesh.

Every sensation I longed for was granted to me: when it was placed on my belly, it hugged the contours of my body,

then rolled down to my cloven mons, where it rested against the swollen flesh above my wrinkled inner labia just long enough to roil and surge against my aching outer and inner lips, like the soft pressure of Amir's lips against my nether ones, before snaking down and around, to press tightly against my deepest crevices, a gelid, yet solid length of exquisite pressure against my throbbing, glistening-wet flesh, then, and only when I longed for it, it compliantly surged into me in a quick fluid rush of inward pulsation that rivaled the penetration of the most skilled man or the most sensitive dildo-wielding hand.

And just enough of it remained outside of my body for me to grasp its free end with my left hand while I massaged my breasts and belly with my right. And even as my fingers touched it, the artifact elongated within my grasp so that I could hold it more comfortably.

My right hand was moving on the downstroke when my fingertips made contact with the table and with the outer edges of the concave nubbed and feathery-filamented device which remained, unused, on the tabletop. Once I touched it, it pulsed in place, fluttering at the edges, until I scooped it up and placed it on my left breast.

The irregularly patterned filaments and rounded nubs pulsated, massaging my nipple and caressing the surrounding mound of softly rounded flesh, and then surged on its own toward my waiting belly, and Mound of Venus. The sensation of the thin fingerlike tendrils running through my short-sheared hair was delicious. And as the other, interior device brought me to the peak of orgasm, I felt the shallow cuplike artifact shimmy back up my torso, until it nestled in the hollow at the base of my throat, gently kneading the skin there, until the last of my orgasm ebbed away, and the round sex-device balled itself up, and rolled down and off my body to the table below.

Across from me, Amir was gasping as the last ripples of orgasm coursed through her body. The alien ben-wah balls emerged, their shining roundness cresting at the mouth of her vagina like small craniums before emerging in all their lubricated pale jade green glory and coming to rest on the bed with the trailing tail of star-tipped tendrils wound around itself like a sleeping cat's tail.

Gently picking up the sated toy, Amir lifted it off the bed and placed it on the tabletop next to my left thigh just as the pleasure rod within me ejected itself with a parting of flesh and a sound like the lingering echo of a kiss. I rested it next to the others on the table before joining Amir on our bed.

We watched in silence for a few moments as the devices—their obvious duties now discharged—slowly resumed their former, seemingly inert state, before I asked Amir, "How long do you think the planet you found these on has been dead?"

"It wasn't really dead-dead, my sweetest. There had been some sort of atmospheric disaster, something which killed the inhabitants but left their buildings and belongings intact. Whatever it was, it didn't last. By the time the planet was discovered, and we were sent to check it out, the air was sort of breathable as long as we augmented it with oxygen every so often."

"So, if these things are 'alive' in some sense, they might have just ... hibernated while the rest of the planet was dying?"

Amir nodded as she reached a hand around my waist and rested her fingers atop my still-lust-swollen mons. "And the 'men' of the planet had similar devices in their chambers. Sort of a variation on the vibrating vagina, or the pulsating pussy ... definitely not anything a woman could use. If only we had some sort of Rosetta stone for their written language. They left writings, but nothing we can figure out. In terms of

cultural development, I'd say they were at a stage of development which was close to our own Greco-Roman empire, or perhaps the late Egyptians..."

I rested my own hand on top of Amir's to better press her fingers against my mound. "But that would mean that these things would have to be organic, no? As in they couldn't easily make them, right? Not advanced enough ... not for interactive sex toys. And these things are plenty interactive—"

"Wait a minute." Amir got off the bed and padded across the soft-carpeted bedroom floor toward the hallway and the living room beyond; a couple of minutes later, I heard a one-sided conversation.

"Yes, it's me. Remember those things we thought were sex toys, in their bedchambers? Uh-huh. Well, was I the only one who was curious or— That's a relief. For a few minutes there I thought I was depraved ... so you and Hernando tried yours out, too?"

There was a pause before Amir said, "So the thing that looked like a dildo didn't work on him? Not at all? Yes, the ones I took worked on both of us at once. All of them worked for us ... No, of course I didn't take home one of those, for what? Well, you two are straight ... that's okay, Lena, no offense taken."

So Amir wasn't the only anthropologist from the alien dig to seek a little alien pleasure. I followed her into the living room, where I mouthed silently while she listened to Lena speak: Did they each try the same toys?

Nodding yes, Amir then told Lena, "Do you suppose that these devices are gender specific, not sex-oriented in a way we'd take for granted based on outward appearances? There's no other way to explain why you couldn't use the dildo on Hernando. After all, it shouldn't have a bias against anal ... It did what? Wouldn't go in, no matter how much you lubricated it?"

A puzzled look washed over Amir's face as I mouthed, But would it go into Lena's behind? She asked Lena the same question and when the frown lines around her mouth disappeared, I knew there was more to these devices than mere convenience of form. They were making sexual choices of their own.

"So do you think they know which sex is which, and prefer the one which conforms to their own shape? Like males with females ... No, I didn't know. When did they find that out?" The frown lines returned to Amir's face but she ignored my silent What's wrong?

I leaned close to Amir and pillowed my head on her breasts. Now I could hear Lena's excited: "—yesterday afternoon, when the transmission from the planet came through. Remember the other team, who arrived just as we were departing? They uncovered a burial vault with a mummified body far more intact than any we'd found. They used a portable CAT scan on it. Inside the pelvis was a fetus, only the body was one of what we'd considered their 'males.' We were wrong about the pelvic formation. The ones we thought were female may have had vaginas, but they didn't carry the young or gestate them! The males did, sort of like seahorses—"

"Then our suppositions based on external genitalia were wrong."

"I gather it was. That would explain why the dildo-thing wouldn't respond to Hernando's body. Apparently, it was actually a device meant for their male, if you consider someone with a vagina male."

"But then, for us, these devices would be, themselves, female?" Amir said, with a wink in my direction, as she began massaging my breasts with her free hand, and I began to knead her buttocks with one hand while caressing the soft, moist spots between her legs with the other.

"I'm not sure," came Lena's voice. "It's so confusing! Amir, Hernando says he thinks these things are sort of ... no offense ... gay, from our perspective. They're having sex, or giving pleasure to, or whatever, to a member of the 'opposite' sex, which in humans would be the same sex. Does that make sense?"

Giving my nipple a playful pinch, Amir whispered in my ear, "Makes perfect sense to me, one woman giving another pleasure, in all the right ways," before telling Lena, "I'll have to sleep on it before I make up my mind about it. Thanks again, Lena." She hung up and then, with both hands free, reached down to grasp both my bottom cheeks. "Care to conduct some more anthropological research with me? I think our subjects are most willing to cooperate with us, no?"

Rubbing my belly and mons tightly against hers, I whispered, "Only if I get to name them. How 'bout genus *Olisbos*?"

"'Olisbos' meaning Greek dildo? Makes sense to me," Amir replied, as we hurried back to the bedroom, and the waiting "ladies," which began to flutter even before we laid eager hands on them again.

As we crawled back on the bed with our "subjects" in hand, Amir asked, "You won't tell them we're not their sort of 'males,' will you?"

"Not as long as it doesn't seem to bother them," I replied, as the twin spheres of the pseudo-ben-wah balls inched into my waiting, longing vagina, and Amir's tubular pleasure wand began its journey toward her own musk-scented cleft. If the devices were aware of our own internal differences, it didn't seem to bother them. After all, I've always said it really takes a woman to give true pleasure to another woman...

Shawn Dell

Crawl Back Inside You

.

L abyris arranged her observatory for the woman who would take her place on the Council of Elders during the next cycle. She was finishing up when Ara hailed her. Labyris activated the holographic communicator and the two women locked gazes. Ara studied Labyris's face, as if trying to memorize the pattern of deep wrinkles there, the signs of Labyris's stature in the tribe. Labyris looked deeply into her lover's dark eyes, and read her thoughts. Ara was concerned about her role in the Ritual, and sought counsel. "Lab, my cherished one," came her thoughts, "how will I nourish you during your transformation?"

"You young ones don't realize the power of your own wiseblood, Ara," Labyris replied in surprise.

Ara lifted her fingertips in farewell, and Labyris responded, reaching out to the holographic fingers.

"I just want everything to be perfect for you, Lab. I love you so much."

Labyris telepathically sent her love as the hologram faded to sparkles in the heavy air. That night, she would make her peace with her accomplishments and failures, reflecting in

solitude and awaiting the sun's return to their hemisphere, when she and Ara would join in the Ritual.

By the time she turned her contemplation skyward that night, Labyris was already shrinking. She stared at the night sky over Venus, deep in meditation. The women of Labyris's collective could watch the women of the East reflected in the night sky, in an atmosphere so thick the reflected light of tribal campfires took the place of stars. They shared experiences, seeking advice through dance and theater performed in the sky. Labyris watched the sky, and waited to report to the Council of Elders, of whom she was the eldest. Her beautifully withered body shrank as the time for the Ritual drew near.

The Venusian sky was lit by the fire dancers in the East, as they too prepared for their Ritual. Labyris interpreted the traces of light and patterns the dancers cast across the heavens, shining trails like the paths of drunken comets. Earlier, when the West had faced the sun, she and Ara had danced the fire dance for the pleasure of their Eastern sisters. Their whole tribe had prepared for the festivities: lighting the fires, dancing the ancient dance celebrating the cycle. She was a cherished one, the eldest, and the guest of honor. She was much sought after for counsel by the younger women, and all had watched Ara enviously as her dark young body danced in the firelight, for she would be the one to undergo the Ritual with Labyris. Labyris awaited the time when she would be with Ara once again.

The two lovers stood back-to-back, as the young ones lit the circle of fire. Labyris had shrunk considerably during the night, and was placed on a pedestal behind Ara. The Council of the Elders prepared Labyris, each kissing her small, wrinkled face, and whispering what contribution she had

made to their own cycles, while the middle cycle women prepared Ara, who would take her place among them after the Ritual passage from youth to midcycle was complete. They kissed her and adorned her smooth skin with painted tribal symbols, anointed her with fragrant oils. Both women were blessed by the tribe and the aura of protection created by the fire of the youth.

The feast was laid out, and the women sat in the circle, Labyris on a large satin pillow, so that her shrinking frame might take part in the festivities. The young ones, impetuous and excited, had begun eating the lush Venusian fruits from each other's laps and drinking the heady wine from each other's mouths. The women in the circle toasted the couple in turn, wishing them pleasure, and making bawdy comments about the Ritual. The elders lit the ceremonial pipe and it bellowed thick purple smoke that hung over their heads in a rich cloud that would last through the festivities. All the women partook of the pipe, drawing the drug into their bodies to tap their erotic energy for the orgy. Their mood was light and high. Anticipation hung thick with the smoke in the Venusian atmosphere.

The lovers were taken to the ceremonial chamber, a canopied cushion on the cliff overlooking the ammonia ocean, encircled with walls of cloth. Two midwives, lost in their own passion, waited outside the fabric shell. Waves crashed passionately on the withered rocks below, while the lovers made one another damp with their own juices. Ara lay over the cool satin of the pillows, and languidly stretched her long, dark body. Labyris, standing a mere twelve inches now, lit the white candles encircling them, making a wish as she blessed each one with fire. Ara slipped into the erotic trance induced by the drug, and relaxed, closing her dark eyes. Labyris admired the feminine mountain stretched out before her, all gentle swells and curves

like the rolling Venusian landscape below, eroded by the chemical waves.

Labyris alighted on Ara's chest like a butterfly gracing a delicate flower. She stroked Ara's full pillow lips, remembering the passionate kisses that had always preceded their sex. Ara gently opened her mouth, allowing her lover entrance. Labyris licked Ara's huge lips with her tiny tongue, savoring the flavor of her lover's mouth. Holding onto Ara's lips, she slid her legs across the satiny expanse of Ara's tongue. Ara held her lover gently in her lips, maneuvering Labyris's lower body to the roof of her cavernous mouth. She gently parted Labyris's legs with the muscular tip of her wet tongue, licking her lover's entire pussy with each tiny stroke. Labyris coated the pointed tip of Ara's tongue with her pleasure, amazed at how strong the sensation was of Ara's huge tongue against tiny, sensitive flesh. She rode it to her first orgasm of the Ritual.

Labyris pulled herself from the hot wetness of her lover's mouth, and rolled gently down the slope of her chest to the valley between Ara's twin peaks. Labyris had shrunk another few inches, spurred by her climax. She sat up with her legs wrapped around the base of Ara's breast, and pushed her own tiny breasts against the soft mountain. Labyris stretched her spindly arms, and was able to reach completely around her lover's breast. Her mouth fit perfectly around Ara's nipple, and she sucked hard. Her sharp little tongue licked around the tender cylindrical knob. Ara moaned loudly, her chest heaving and gently lifting Labyris with each breath. Labyris rode the waves, rubbing her own quickening nipples against Ara, squeezing and kneading the warm flesh with her tiny hands.

Labyris crawled down Ara's belly to the crater that was her belly button. She caressed the dark hole gently, knowing it was attached to the sac that would nourish her transforma-

tion with the wiseblood of her lover. Farther down, she saw the ankle-deep curly hair covering her lover's pubis. Ara spread her legs, gently opening her labia to reveal her huge butterfly-wing lips. Labyris squatted on her pelvic bone to admire the enormous vagina spread out before her. The scent of her lover's arousal engulfed her, blocking out the sharp smell of the Venusian atmosphere. She savored the sweet smell, knowing she would never smell anything else until after her rebirth.

Labyris, standing only six inches now, leaned over the ridge of bone and gently massaged her lover's labial lips. Ara moaned. Labyris reached for the large hood of skin, and gently smoothed it, exposing her lover's clitoris. Labyris took the glistening red nub into her mouth, and licked it with her tongue. Ara bucked, lifting up her hips and Labyris's tiny frame. Labyris slid her arms smoothly through the folds of skin, reaching into that warm, wet hole, that she would soon be calling "home." Ara's clit throbbed in Labyris's mouth, as her hands teased the grasping muscles of Ara's vagina. Ara quivered and moaned as waves of her orgasm swept over her like a Venusquake, creating a low rumble, deep in her loins.

Labyris slid her head, shoulders, and arms inside her lover's wet vagina and felt the muscles grasp and massage her, trying to pull her in deeper. Labyris spread her own legs wide, the only part of her protruding from her lover's mound, and anchored her feet on Ara's hip bones. In this position, Labyris's tiny pussy rested against Ara's bulging clit. She rubbed herself hard against the small projection and felt Ara's muscular vagina close wetly around her torso. She made love with her whole body, sliding her outstretched arms deeply inside Ara, feeling the hot flesh engulf her head and shoulders. Each time she pulled back out of the sensitive opening, her own tiny vagina rubbed against the mound of clit, and

Labyris shuddered with pleasure. She repeated this motion, using her whole body to please her lover. She slid in and out of Ara, like a fish swimming upstream.

Ara responded with primal moans and vaginal contractions. Labyris rode her through another orgasm, her own body, hot with passion, rubbing harder against the giant clit. Soon Labyris joined in her lover's climax, clamping her small legs around Ara's labia and clit. The giant, curtainlike folds of Ara's labia pushed out between Labyris's scissored legs. She squeezed gently so that Ara could feel her tiny body tremble with the intense pleasure of their coupling. Delicious orgasmic waves swept Labyris's tiny body, and her lover's goddesslike proportions, in rhythm with the beating surf outside their love nest.

Labyris released her hold on Ara's sensitive folds. Ara relaxed, allowing her lover to slip farther into her lush, fragrant channel. Labyris curved her body into Ara's vagina; only her knees remained outside the tender opening. She felt the vaginal contractions, and smoothed the slick walls with her tiny hands. She slid her hands up behind the pubic bone to the sensitive, ridged area behind Ara's clit. Ara's body shook violently as her lover explored territory she could never see before. Ara's muscles clenched tightly around her tiny lover holding her still, then excitedly contracting. Labyris moved her body gently inside her lover's wet heat, causing a wave of honey to crash around her. Coated with the warm ejaculate, she became slick and smooth inside the lubricated flesh walls. Ara's vagina opened wide, the muscles grasping and pulling her lover into the dark, wet, depths, the deepest point of her womb. Labyris was completely inside her lover now, engulfed by the strength of their passion.

Labyris's journey ended deep inside her lover's womb. She relaxed into Ara's warm flesh, lulled by the rhythmic beat of Ara's heart. She felt warm and comforted. Nothing could

possibly harm her here. Ara's body sent electric impulses through nerve endings to Labyris, giving her the sensation of love and belonging. She realized her cycle was completed. It was time for her transformation. Labyris took a last, deep breath, inhaling the lush scent of Ara's sweetness. Gradually, and without regret, Labyris let go of consciousness, and allowed her tiny body to melt into Ara's womb.

Ara realized almost after the fact that Labyris was no more. She looked at her imperceptibly swollen belly. She caressed it gently with her hand, remembering her sensuous life with Labyris, and their intense lovemaking. Momentarily, she allowed sadness to cloud her ecstasy. But now the two lovers' bodies were entwined at a level she had previously only imagined. As the cells reorganized inside her womb, Ara knew that in a few rotations, she would once again have the most intense orgasms a woman could have. A small woman, enriched with Ara's wiseblood, would crawl out of her womb, and would grow very rapidly, in dialectic proportion to the swift shrinking of Labyris. She would take her place in the tribe, fall in love, and complete her own ritual someday. Ara hoped the woman in her womb would be most like Labyris, and would fall in love with her as passionately as Labyris had. She missed her aged flower, and would mourn joyfully for her.

Ara sighed, and stared at the bright points of light sweeping the Venusian sky, the remnants of the ceremonial revelry on the other side of the planet. Ara wondered if there was an Eastern sister staring into the sky, watching her tribe's lights and pondering, after completing the Ritual. A sense of completion and continuity swept over Ara. She stood, and parted the fabric curtains to survey the frolicking women still pleasuring each other. Ara left the love nest, and took her place among the tribe, just as the Venusian sun heralded the close of the Ritual, and the beginning of a new cycle.

Beverly Heinze

Gone to the Spider Woman

Maxine peered at the neat stack of mummy casings. *Quite a collection,* she thought. Depressing, though, since more than one of the dried-out husks resembled an ex-lover. She scanned them, searching for Erryl's likeness.

She crept closer. The empty shells, yellowed and dry as parched grass, seemed to represent the forsaken and hollow dreams of their former occupants. With two fingers, she traced the profile of the nearest face, that of a young woman who would now have the perfect nose and finely formed mouth of a goddess. The casings, papery and waxy like insect wings, rustled ominously.

Maxine hung her head. Clearly, it was foolish to have hopes and dreams. The Spider Woman would never break a past client's confidence. But maybe, since she liked Maxine, maybe she would reveal something about Erryl's fate...

"It is taking a little longer for that one," a perfunctory voice stated. Dr. Yu, the famous Spider Woman, was glaring at Maxine with eyes dark and glittery as carbon steel. "She requested, ah... deep changes."

"Deep changes, as in complete changes?" Maxine asked.

"All changes here are complete."

"And then, after completion...?"

Dr. Yu glanced at the small window behind Maxine. "Then she will... fly away."

"Sorry to hear about you and Erryl splitting up, Maxine," Ambassador Lovejoy said. "You two were our top team. The best." He leaned back in his delicate little Hokkidu chair and twisted a lock of frizzy hair onto a finger. He'd gone gray over the years, gained weight, and acquired a battery of vague diplomatic gestures. "She's gone to the Spider Woman, I suppose?"

"Don't they all?"

"Not you. You haven't."

"No, not me," Maxine sighed. As she reached across the desk to pick up the latest gel file, Lovejoy shrank back reflexively, lowering his eyes.

Maxine put on a professional face and made a show of perusing the file. Many years ago, new on Hokkidu, Lovejoy had been a curious and indulgent emissary. "May I?" he'd asked, reaching out to touch the translucent skin. "Beautiful," he'd whispered. "Like stained glass..." He hadn't even grimaced at the mild shock.

Now Maxine stifled the urge to give him an accidental but punishing jolt. Instead, she said, "What's on the agenda?"

"A meeting with the Pribbolites," Lovejoy answered. "They want to negotiate a trade." He formed a tent with his well-manicured fingers and hid the bridge of his nose, appraising Maxine. She knew that a lie would follow this mannerism.

"They're not saying what they want?"

"Of course not. They'll let us stew a bit first." He picked up a pen and lightly aimed it at her. "Word has it they want a nullion."

"What!" Maxine spluttered. "They've never wanted a person before! Mineral rights, trade incentives, tax breaks. But not one of us! They don't even like us!"

"Who does?" Lovejoy answered. "Maybe they want to find out how nullions tick. Maybe you fascinate them."

"Sure." Maxine fought to control her anger as Lovejoy awaited her reaction. "Obviously we fascinate everybody," she stated flatly. "I suppose I'm to discover their motives?"

"Yep. Read the file and go out and see what you can learn on the streets. Your new partner is waiting outside. Noby is her name. Go take a look," he smiled. "Go ahead. I'll see you in a couple of weeks." He stood and swept an arm grandly toward the door. "And again," he added, "I'm sorry about Erryl."

Not as sorry as I am, Maxine thought. Of all the partners she'd had, Erryl had been without equal. Together they'd driven the Pribbolites crazy, disclosing more of their secrets, ruses, double-crosses, and Machiavellian twists than any other team. The Pribbolites, who thrived on intrigue, were masters of diplomacy on every planet in the confederation. But here on Hokkidu, where nullions had found a niche in the diplomatic environment, they foundered shamefully. *Damn fuzzballs,* Maxine swore. She hated them for their self-important strivings. Why did such an eminently protected race crave so much subterfuge?

Meanwhile, her new partner was staring at her, taking in the fireworks. *An angry nullion is surely a fearsome sight. While her lungs emanate nuclear yellow sparks, her blood turns a bright crimson and rushes to her vagina, where a dazzling red glow embarrasses one and all.* "Are you Noby?" Maxine asked.

"Yes." The woman got to her feet with the grace of a sun-warmed cat. "And you're Maxine Cruz," she stated.

"Yes." Maxine took a deep breath and directed her body to stay cool. "We're to be partners," she said.

"So I'm told."

"I take it you're not too happy about it."

"No."

"May I ask why?"

"Your, ah, reputation as an agent is good," Noby answered. "But for this job, one needs a strong commitment..."

"I've never walked away from a partner," Maxine interrupted. "Or a relationship."

"I know."

They've all left me. A dozen of them. But not because I've driven them away. Maxine sighed. "I guess if you stick with one job long enough, everyone leaves you."

"Could be."

"Well, let's make the best of it," Maxine said, flapping the crinkly gel file at her new partner. "This will interest us both, I'm sure. Let's read it over and talk. Maybe we can figure out what's cooking with those assholes from Pribbolis."

As they walked through the bustling Trade Nexus, the crowds parted like water before a ship's prow. Some citizens smirked, some flinched, but most just moved aside automatically. After all, one inadvertent brush with a nullion could shock them into a seizure or a swooning coma, depending on their own mood at contact. But Noby seemed to have a talent for avoiding the masses: as they streamed past, she left no wake.

But then she did something both surprising and endearing.

From nowhere a group of young Pribbolites had surrounded them, leering and snickering. "What have we here?"

the hairiest one sneered. "Gizzards on parade?" He nudged a tawny-furred pal and snorted like a Pekinese dog.

"Walking cadavers," another said.

"Show and tell! Let us see your...!"

Suddenly Maxine noticed that Noby had nulled out. In her place, just about waist-high, jogged nothing more than a column of shit!

"Perfect!" Maxine laughed, unabashed. Then, as the embarrassed boys dropped back, Noby reappeared, straight-faced.

"Breathtaking social commentary," Maxine said. "Now, let's get out of here before those jerks cough up a hairball!"

Noby was still angry. They'd read the file and ingested the gel along with the crackers and beer Maxine had supplied, but her new partner still fluoresced a dim pink glow. "Those pups couldn't have touched us," Maxine said. "They're just kids, after all."

"They're always touching us," Noby spat. "More than we can gauge, they manage to touch us!" Sparks shot from her eyelashes and her fingertips glowed as she reached for her beer.

"Careful. You'll make it go flat," Maxine pointed out.

Noby smiled, showing perfect small teeth. She was a derivative of the oriental stock that had first colonized Hokkidu, a quirk of fate that had lowered her further in the esteem of the Pribbolites, the ultimate exploiters of galactic wealth. To them Maxine was an arriviste, but Noby was a custodian and a servant. That they were both nullions merely accentuated their lowly status.

"Those kids' behavior is just another gimmick," Maxine said. "Meant to unnerve us. It's second nature to them, no matter what age they are."

"I know. Born assholes." Like banked coals, Noby's black eyes had dimmed in intensity. Maxine knew it was time for the test.

"We'll be attending a party at the Pribbolite consulate four days from now," she said. "As partners."

Maxine had attended a thousand such parties, voided to invisibility by her partner, and gathered the state gossip that such exclusive soirees produced. It took a lot of control, a substantial amount of energy, and immeasurable nerve to do it. The penalty for such eavesdropping was retroversion. And no one wanted to finish out her life as a sentient turnip. "So," Maxine went on. "Perhaps we'd better check the circuits."

Noby's wing-shaped eyebrows peaked. "Sure." She set down her beer and stood up.

Facing one another, the two nullions first blanked themselves out. At close quarters, if in agreement, a pair of them could act much like an anode and a cathode, their sensory output combining to one big zero. "Fine," Maxine murmured. "I can't see you at all, and now I can see through you. Shall we reconfigure?"

There was no answer. Maxine fidgeted, adjusting her image to a faint waver. "Noby?" She waited patiently, as she always did at this juncture. Two nullions sharing one another's energy field almost always end up in bed.

"Why not?" Noby finally answered, beginning to glow a faint pale gold.

Maxine observed her closely, just as she knew Noby would be watching her.

First Noby's skeleton came into view, a bright neon blue. Then her integumentary system, including lungs and digestive tract, became a pale silver color, flat as pewter. Next, her blood vessels and heart appeared, lymph bubbling along like soda water, lime green in color. Her nervous system then showed up, red and glistening like thin lava rivulets. For her

finale, Noby's reproductive organs came into sight: Maxine found herself gazing at ovaries like pearly eggs, a womb of black velvet, and a royal purple throbbing tube below.

Holy shit! Maxine was impressed. This woman was a master of self-control, and moreover, an artist. "Geez," Maxine murmured. "I hope I don't put you to sleep."

Noby's dark eyes, now glassy carnelian, held no awe as Maxine whipped her body's constituents into a frenzy of whizzing corpuscles and glissading molecules. Then she sent streamers of eerie fire from her fingertips. But not until the fire coalesced into two will-o'-the-wisps that danced about and lit upon her royal purple nipples did Noby smile appreciatively.

"Wow," she sighed, taking Maxine into a loose embrace.

"Absolutely stunning," Maxine uttered. They slid carefully to the thick carpet, pressing close. She barely had time to slip her thigh between Noby's powerful legs before they both climaxed, producing a veritable supernova of white light, shooting stars and frothy comets. "Holy smoke, sweetheart," Maxine gasped. "Who said lightning never strikes the same place twice?"

Noby smiled faintly and lay her head back upon an upraised arm. Maxine turned so that she could see her lover's entire body as it subsided into tranquil repose. It was very much like observing a city at dawn: after the sun chases the stars from the skies, building lights and streetlamps blink off one by one. Then a cityscape emerges, its riches and secrets revealed. But, Maxine noted, this nullion's skin continued to glow and shimmer with all the colors of the rainbow. She dared not risk a caress.

"Did we meet standard?" Noby asked.

"Perfect attunement," Maxine answered. "We'll be top-notch agents. No one will ever see, smell, feel or hear us when we're working together."

"You're the expert."

"Look, Noby. It's true I've been doing this longer than anyone else, and it's true that all my partners have gone to the Spider Woman. But almost all nullions choose that route." Maxine sat up and ran her eyes over Noby's lovely body. Soon, if she slept, all its tissues and wastes would be visible to the naked eye. How many times, as she grew up, struggling to control her own body, had Maxine seen the revulsion in her family's eyes? And strangers' as well. "Face it, Noby. It's a tough, tough life. And when you grow old and careless, it will be an unendurable one."

"And this job just adds extra stress?" Noby's heart-shaped mouth was curled into a sneer.

"It does. I can't help it, but it does."

"Why haven't you gone over then?"

Maxine hesitated. Oh, how she yearned to reach out and stroke Noby's soft, peachy cheek. Instead, she clenched her fists into useless stumps. "I don't want to, Noby," she answered. "When a nullion gets reconstructed, she disappears into the masses of normals and never looks back. No one can trace her origins. She starts a new life."

"So. That's the objective."

"So it is. But I like what I am. And I'm good at what I do."

"The best," Noby smirked.

"I am."

"If you're so good, why don't you touch me?"

"You know we can't, after..."

"We can," she whispered. "We won't self-destruct," she laughed. "I promise."

Maxine extended a hand, fully expecting to be shocked and burnt. But instead she connected with warm, tender flesh, soft as a silken pillow, inviting as warm summer rain. "Oh," she gasped, embracing Noby. "This is unheard of..."

"First time for everything," Noby murmured, guiding Maxine's hand downward.

For all her experience with different lovers, Maxine had never really gotten to enjoy the tenderer aspects of lovemaking, for her close contacts with a nullion were always short, sharp, and explosive. She marveled at Noby's luscious body, running her fingertips over every inch of it.

"Amazing," she breathed. She curled a damp lock of Noby's pubic hair around a finger, then moved down to take a look at the part of a woman's body she'd only glimpsed before. Noby was quite wet. Spying a glistening nub amidst the rosy-brown folds of skin, Maxine gaped. "Why, it's beautiful down here!"

"Oh, Maxine," Noby laughed. "You sound like a tourist."

"But, I've never seen..."

"I know."

Maxine edged a little closer and gently inserted a finger.

"Oh," gasped Noby, lifting up to meet her.

Maxine, still worried about runaway galvanic responses, carefully replaced her finger with a thumb and lay herself fully upon Noby's body, moving very slowly. But within moments, they were both bucking wildly, bodies pressed close and entwined like jungle vines. Soon Noby arched her back and cried out, to be followed immediately by Maxine. For the second time in her life, Maxine saw stars.

Exhausted, she lay limp upon her lover, who had suddenly grown cool and turned a lavender color. "Are you okay?" Maxine whispered.

Noby did not stir.

Maxine pressed her lips to Noby's throat, seeking a pulse. "Noby? Oh, no, I knew we couldn't..."

Suddenly she felt the flesh ripple beneath her, then it shuddered. Was Noby having some kind of fit? "Noby!" Maxine cried. Raising her head, she saw that Noby's mouth was open and she was starting to laugh.

"Oh, Maxine," she gasped. "For a moment I thought you'd expired right on top of me, you were so still, and heavy as a stone!" She cupped Maxine's cheek with a hand. "But then you came back. I'm so glad!"

"Me, too, Noby. Me, too."

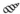

The next few days found Maxine out on the street with Noby, mingling with neighborhood nullions and street agents friendly with the Pribbolites. Evenings, Maxine waited anxiously for her partner to show up at her apartment to spend the night in her bed.

All nullions, by their very birthright, were mysteries to most folks. But the way Noby casually surpassed the usual nullion limits left Maxine flabbergasted. *Really,* she admitted, *this woman is unmatched in her ability to control her body, as well as influence mine. Furthermore, as sexual partners nullions generally burnt one another out very quickly, and sometimes literally. But,* Maxine thought, *that doesn't seem to be happening with us.*

She tensed. Noby was approaching. Maxine could feel it in every cell of her body.

"Hi, it's me," Noby called, poking her head through the door.

Maxine stood up, her knees weak. "Come on in, hon." Then her mouth dropped open and her pulse quickened.

Noby had swaggered in and struck a defiant pose, hands on hips, pelvis thrust forward. "Well?" she laughed. Clearly, she was allowing her body to speak for itself.

Maxine gaped. Just behind Noby's left breast a lurid pink rose fluttered rhythmically, as if it had just awakened to the hot sun. And, below her navel, a crimson red barrel smoldered, dripping as if glazed with honey. "Well," Maxine managed to utter. "Thanks be to our ancestors for gifts such

as these." She placed the flat of her hand close to Noby's cheek. "Learn anything new this afternoon?"

"Same old stuff, Maxine. The Pribs are leaking a dozen contradictory stories." She looked Maxine up and down slowly. "They do seem to want one of us for something."

"Hm. I wonder what that could be," Maxine smirked.

"I know who knows, though."

"Who?"

"Lovejoy."

"Ah." Maxine felt a flush of anger suffuse her body. Noby leered appreciatively.

"Really, Maxine," she said. "I don't know which is more attractive about nullions: their complete lack of control, or their total control." Taking Maxine's hand, she led her into the bedroom. Hokkidu's periwinkle blue moon was just rising over the evergreen trees outside the window, and a soft breeze carried the mixed scent of bayberries and jasmine into the room.

Lying upon the bed, Maxine pulled Noby into a forbidden embrace, surprised again that no sparks scorched the air. Surely their combined energy could light an entire apartment building. "Amazing," Maxine murmured. Beneath her skin a fizzy current of bubbles steamed from cell to cell, organ to organ, like plasma leaping between all the suns of the universe. "I've never felt anything like this before..."

"You tell that to all the girls," Noby smiled, slowly tracing Maxine's contours with her fingertips.

"Really, I never knew how erotic a touch could be."

"Hm." Noby drew back and gazed at her. "I guess I never did either. This is a first for me."

"Probably a first in history..." Maxine gasped. Noby's fingers were inside her now, moving slowly, searching, caressing ever so gently her most sensitive parts. Soon her head was between Maxine's thighs, resting momentarily.

"Now for another first," she whispered. Her tongue found Maxine's clitoris and grazed it with the lightest of strokes, creating a faint electrical pulse.

"Ah, Noby... What are you...?" Maxine gasped. She reached down to grip her lover's shoulders, but Noby quickly grasped her hands, completing a circuit. "Oh!" Maxine cried out, throwing her head back and arching her spine. She gritted her teeth as spasms rippled up and down her body, and clung to Noby like a motherless child. Then, through red-tinged eyelids, all the stars of the skies plunged toward her and exploded into billions of radiant particles.

Finally, Maxine lay still. From nowhere a lambent breeze came to caress her body, the breath of angels, she guessed, accompanied by the exhalations of all the demons of lust. "Good god, Noby," she groaned. She opened her eyes warily, fully expecting to find the room in ashes.

Noby's head lay in the little gully between Maxine's belly and thigh, warm and buzzing with tiny lights at the end of each fine black hair. Carefully, she crept up alongside her lover and kissed her gently. "Ah," Maxine sighed. *I can taste myself on her lips, salty, pissy, loamy. And maybe a little ozone...*

She began an exploration of Noby's warm and supple body. Red ribbons, white strings and blue ropes plied the tender flesh like the lines on a holo-map, while wheels of light lit up her midline from crotch to brow. Cold heat thrilled Maxine's fingertips. "Geez, Noby," she sighed. "You're an amazing woman." Maxine pulled her close, and just for one second, hugged her with all her might.

Driving out to the consulate grounds, Maxine found herself reliving every moment of the night before. Never had she experienced a woman so thoroughly, never had she experi-

WORLDS OF WOMEN

enced herself to such a degree. *How soft we are,* she mused, *tender as new buds in the gentle spring. What delicious tastes and scents we have. Truly, interacting with a nullion at a distance, however minimal, is no comparison to actual physical contact with one. No wonder the normals are so smug,* she thought. *They're always touching one another, rolling their eyes and grinning, and sometimes they even try to touch us. Until they get burnt a few times.*

She glanced at Noby, who was steering the little car down the narrow country roads like a taxi driver, one arm hanging out the window. *She must enjoy the wind blowing against her,* Maxine thought. *Erryl, for all her strength and willfulness, could never have enjoyed herself so patently, would never have appreciated her own body the way Noby does.* What was different about this new woman?

Nullions, the result of research on bio-sensitivity, could be traced back to a dominant gene created by the same Dr. Yu who now offered them reconstruction. A specialist in rejuvenation, Dr. Yu herself was said to be more than two hundred years old. And, though rumored to be colder than a popsicle, she never turned down a nullion's request. "Those burn most mournful," she said, "who burn alone." And no one was more alone on Hokkidu than a nullion.

Maxine tore her eyes away from Noby. Did she dare become familiar with the curve of her neck, her graceful hands, her stalwart thighs? Someday those features would all return to the Spider Woman to be made over. Maxine ached in longing already, knowing this. "Do you see your family very much, Noby?" she asked, trying to change her line of thought.

"No."

"Me neither. They don't spurn me, but they're clearly uncomfortable in my presence. They're always waiting for me to slip up and show them my insides."

"I know." Noby's black eyes were overtaken by a shadow, her jaw grimly set. "My mother is a doctor," she said. "You'd think she could have used me to learn about the human body. From the inside out."

"Ha," Maxine laughed. "A missed opportunity, to be sure."

"Speaking of same," Noby stared straight ahead. "How could you have let Erryl go? You were happy together, weren't you?"

Maxine recalled the last evening she'd spent with Erryl, an evening of anger and recriminations, as she sought to persuade Erryl to forgo reconstruction. "You'll be like everyone else," she'd yelled. "Nothing special!"

"No, Maxine," Erryl had replied. "I'll be accessible." She'd sighed and turned a sad bluish color that Maxine associated with pain. "I'm tired. Tired of being an untouchable."

Maxine longed to reach over and place a hand on Noby's thigh. "Well," she said, "you're right. We were happy together. And god knows it's hard on a person, to be happy only when in the company of another. It's just grindingly hard."

"Oh."

The party was the usual semidecadent Pribbolite soiree, with the guests gathering in underlit corners to gossip and practice Machiavellian maneuvers on one another. Maxine, in the state of invisibility that only two nullions could attain, made the rounds, eavesdropping. Annoyed by their thick lustrous pelts and superior airs, she hated mingling with the Pribbolite diplomats. Stocky as furniture and graceless as robots, they took control of every conversation and made it a mission to discomfit the colonists of Hokkidu. Maxine had grown so weary of their posturing that she almost missed the one small group that was quietly not attempting to outmaneuver one another. She and Noby crept closer.

"...for a pet," one creature was saying.

"Really," a large brindle fellow answered. "Fancy that."

Maxine was intrigued by this little group. The males, sleek and robust, were shorter than the slender, blond-furred females. Their eyes and teeth glittered in narrow vulpine faces, their ears, though mostly hidden, stood erectly attentive. And they all wore fancy sashes, armbands, belts and boots of fine cloth. All denizens of Pribbolis eschewed leather.

"Ugh," a regal female exclaimed. "A laboratory specimen is more like it. Really, this is most unsavory."

Suddenly the hair on Maxine's neck stood up. Uh oh. She stifled a gasp as her stomach plummeted like a skylark. What was going on? She scanned Noby for signs of fatigue, but saw nothing.

Then something more inexplicable happened. A young silvery blond female detached herself from the group, turned slowly and stared directly at Maxine. *She can see me!* Maxine's heart pounded like a kettledrum, threatening to imbalance her perfectly tuned state. Aghast, she saw that the tips of her extremities were taking definition, wavering like guttering flames. *Shit!*

Another head turned. "Look!" someone cried. "Something's there!"

As one, the entire group spun to stare at Maxine.

"A spy!" a russet male cried. "Security. Get security!"

Maxine raised her arms to ward off the approaching Pribbolites, but her fingertips produced only pale yellow sparks, the weakest of jolts a nullion could muster. She was losing power, fast.

Then, from a doorway, two dark figures lumbered toward her. She heard the whispery buzz of a sump gun, then felt its impact as her nerves caught fire and depleted themselves in an instant. "Ahhh," she sighed, as her lungs shut down and she slumped to the floor in slow motion.

From her new viewpoint Maxine gazed stupidly at the two Pribbolites thundering toward her. With each ungainly step their glossy coats shook like rippling fields of grain, and their breath came in guttural, growling explosions. She waited numbly, resigned to their wrath. But to her astonishment the two guards stopped short. With bulging eyes, they exchanged a brief look of bewilderment, then threw their heads back in an ear-splitting howl.

Cripes! Is that some sort of war cry? Maxine wondered. But then her own eyes popped, for a bolt of crackling blue electricity struck the two Pribbolites and they lit up like arc-lights! Shrieking like banshees, they whirled about the room in a convulsive frenzy, till one bit through his tongue and sprayed the horrified guests with black blood.

"God... damn..." Maxine whispered. How could this be happening? Her eyes rolled back and she sank helplessly into a black void. Where was Noby? And what was that terrible smell?

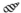

An eon passed before she awoke, flat on her back upon a cushioned table. She could not lift a limb, turn her head nor move her lips. Yet she breathed. A marionette unstrung, she thought. Then she remembered the Pribbolites, the flames, the screams, and Noby's presence. And someone else's presence, as well! She groaned.

"At last," a voice answered. "I'd almost given up."

Erryl! The face in Maxine's peripheral vision was wrong, but she knew Erryl was nearby. She struggled to speak.

"No, listen to me, Maxine," Erryl said. "You can't move. You've been de-magged and de-juiced. Your lifesigns are nearly flat." Her voice quavered. "You're scheduled to be retroverted. It's not so bad," she went on quickly. "At least you'll still be alive. You'll just be a little less lively."

There was a silence while Erryl struggled to stick a charged patch on either side of Maxine's mouth. "I'm breaking an agreement, but maybe you'll be able to talk a little now."

Maxine managed to focus on Erryl's face. Though still delicately chiseled, it was now covered with fine glossy fur. Oh, Erryl. "You...," she gasped.

"Yes, it's me, Erryl. I knew you sensed me there, at that party, Maxine! It's amazing. Your powers are astounding. Every atom of my body has been replaced."

"Not ... your soul," Maxine managed.

"Ah, maybe." Erryl reached out with a silver-blond furred hand, but withdrew it. "Listen, Maxine. I can't stay. I'm only here because Dr. Yu demanded it. You and Noby killed two mercenaries. The Pribbolites insist on retroversion."

"Noby...?"

"Noby's gone."

"Gone?"

"Oh, Maxine. She combusted."

"What?"

"She appears to have blown herself up. There was lightning, smoke, white light."

"When?"

Erryl did not answer.

"When!"

"After her capture. During interrogation," Erryl said. "It was pretty disturbing, apparently. Lovejoy is hopping mad."

Sure. A mistake. The wrong nullion had been given over to the Pribbolites. "Oh, Noby," Maxine moaned.

"Listen," Erryl said again, drawing close to her ex- lover's ear. "Dr. Yu has offered to reconstruct you as a normal human being, not a rejuvenate, not a Pribbolite, not a retrovert." She hesitated. "Though she could get in a lot of trouble for this, she's adamant."

Maxine suddenly recalled what Noby had told her about the Spider Woman. "Our mother, more or less," she'd said. "She created the first one of us two hundred years ago. To her, we are not unlovely. She suffers greatly because no one, including ourselves, finds beauty in us. But she's always willing to change a nullion into whatever we want," Noby had snorted. "Just like a mother."

Noby. Maxine remembered her last few days with her, hours in which she'd learned the exquisite pleasures of the flesh, how to enjoy another body, smell it, taste it, feel inside it.

But suddenly Dr. Yu's stern face was hovering over her, her sharp eyes bearing in on Maxine. "Shall we proceed?" she asked. She lowered the spinnerets for which she'd gotten her name, a jawlike device designed to weave a silky chrysalis around a body. Then Dr. Yu would pump the genetically altered hyper-viruses and the megadoses of nutrients into it and await transformation.

Dr. Yu's hand trembled as she adjusted the dials. "You were the best, daughter. You and Noby were head and shoulders above everyone else." She reached to remove the electrodes from Maxine's cheeks. "You have decided to reconstruct as a normal?"

"Mother," Maxine managed to utter. The word caused her to remember her own mother's ambivalence, how often her eyes had reflected repulsion. "This body of mine, one you bestowed, was cherished by some." Maxine smiled faintly. "But by none more than myself."

"Aha. I see."

"Then you cannot make it less than it is."

Dr. Yu was quiet for a long time. Then she placed a hand upon a button rarely used by one who specialized in prolonging life. "Yes, daughter," she agreed.

Jessy Luanni Wolf

The Gift of a Moonlit Magic Mermaid

Nothing I did seemed to work. I tried smiling, not smiling; looking sweet, looking mean; talking with intelligence, acting stupid. Nothing worked. I still went home alone and my only lovers were in my head. Take last Sunday, for example.

It was the annual Womon-Loving-Womon picnic in Long Beach. Hundreds of wonderful women were there, in a beautiful setting, relaxing and being happy, eating and getting erotically oral on all the gorgeous food. Surely at the picnic, I thought, with all these lesbians from different sorts of backgrounds, surely I'd be able to find one for me.

It was a clear, sunny day, and the bright green trees made an almost-too-perfect picture against the blue sky. I came to the picnic with my friend Bonnie. Bonnie was younger than I, with long brown hair and sparkly brown eyes. Bonnie never had any kind of trouble, and she thought my predicament was funny.

"It must be in your head, Linda," she told me at the picnic. "All you have to do is relax and be friendly. If nobody comes to you, just get up and go to them!" She looked around the

picnic area then, and grabbed me by the arm and pulled my ear to her mouth. "Look at that attractive woman over there," she demanded and pointed with her eyebrows at somebody off to my right. A tall, athletic-looking Chinese woman was watching us. Bonnie smiled encouragingly at her and I tried to. The woman started walking over to us. "Go on, be friendly," Bonnie whispered at me, and then, the woman was there.

She gave me a glance and turned to Bonnie. "Is this your lover?" I still remember the exact tone of her voice, and the way she looked at Bonnie.

"Oh, no," Bonnie said, "she's my very good friend and she's a wonderful person." Bonnie smiled at me like a proud mother.

"Good," the woman said as she pushed herself in, to sit between Bonnie and me. She turned her back on me and said to Bonnie, "So, are you from around here?"

I don't remember the rest of the conversation, because not much of it was directed at me. A few times, Bonnie tried to get Pat's (that was the athletic-looking Chinese-American woman's name) attention back toward me, but it was hopeless. I ate all the potato salad and both Bonnie's and my sandwiches while they talked. I left them a couple of apples. Then I got up and walked around, looking at everyone being happy. When I got back to our spot, Pat and Bonnie were exchanging phone numbers.

"It was nice meeting you," Pat told me, and shook my hand. "I'd love to stay and talk more, but I have to go to work You take good care of Bonnie," she told me, very seriously. I smiled at her.

After she left, Bonnie said, "See? Wasn't that easy? All you have to do is put forth some effort!"

We stayed a few more hours, and Bonnie introduced me to three more women. They all left with Bonnie's phone number. Finally she gave up on me and we left.

"I don't know what's the matter with you, Linda," Bonnie told me on the way home. "You just aren't friendly; you don't even try. All you have to do is smile. I think you just like to be alone." We got to my place and she let me out. "Well, maybe next time. Love you," Bonnie told me and drove away.

I looked up at the sky; it was dark now, and the moon was up. She was full. I soaked in her light for a bit and went inside, full of moonbeams, thinking, *Well, it was a nice day, and Bonnie was fun to watch, and none of those women were my type anyway, and I think I'll have a nice lunar ritual tonight and then a glass of wine and settle down with my cat and a good book.*

I opened my door and walked into my home. I always liked to come into my home. Everything was the way I liked it. My furniture was old and comfortable, with crocheted afghans thrown on the sofa and easy chair. My grandmother made them for me, years ago. They were colorful, crazy designs, made from her old scraps, left over from other projects. One of Grandma's afghans was just right for wrapping up in as I curled up to read. I had lots of houseplants to keep the air clean and pictures and statues of goddesses all over, from many different cultures. I preferred mermaids, so at least half were sea goddesses. One wall was dominated by my 150-gallon aquarium. Angel fish and little blue neons swam slowly back and forth. After many years of owning an aquarium, I had settled on these two types of fish as the ones I most enjoyed living with, and the only others in the aquarium were the algae eaters and the catfish, vital for a clean tank.

My cat was curled up on the sofa, and she looked up at me as I shut the door and smiled. She told me she'd had a really nice nap while I was gone and hadn't missed me at all. Her name was Ariel. She was white, with gold eyes, and very vain.

"Well, I certainly missed you," I said, "I could have used some conversation while Bonnie was meeting women."

Ariel told me I should have known better than to believe Bonnie would entertain me; I'd already experienced enough outings to know exactly what to expect; it was always the same. So, she told me, it was my own fault if I were disappointed.

"Hey, Ariel, it wasn't all that bad. I liked watching all the women and Bonnie is always fun to watch. I'm not disappointed."

Ariel smiled at me .Then she told me that I should be very content, because I had her and she was really all I needed.

I made us some dinner, tuna for Ariel and quesadillas for me. We didn't eat yet; instead, I set it aside on the table. After drawing the circle and calling the four directions into it, I lit the candles, opened the curtains to show the moon, and invited the Goddess down to join us.

Since it was the full moon, I invoked Selena. I anointed Ariel and myself with Love #22 oil and we burned "wishes" incense. We sang the moon song until we started to buzz; we danced in tune to our song, whirling and stomping to raise up energy. We chanted the ritual Isis chant into a strong mystical magical place.

Ariel's eyes glowed and I felt the tingle of the magic running all through my body. I felt the warmth of the Goddess inside and all around me; I glowed with Her energy.

I had always just celebrated, never petitioned for any favor from the Goddess. But Ariel spoke to me in the full dizzy trance time of the magic, and she told me to ask the Goddess to help me with my desire. I closed my eyes and I saw the fountain of light running all through my body and up through my head, up and around and down again, magical energy renewing and renewed in me. Then I saw

Selena, sparkling with moonbeams. Her smile caressed me. I felt the fire of Her love fill me with happiness. I thought about what Ariel had told me. Was I lonely? Did I want a lover? Could I even be honest about whether I needed a woman in my life or not? I felt my body, yearning, and without considering exactly what I yearned for, I asked the Goddess for love.

"Selena, Goddess of the full moon, beautiful and glorious, make somebody love me, please!" Shining brightly, glorious and magical, the Goddess smiled a warmer and bigger smile. Her smile embraced me and I felt warm, light, buzzing and happy. I spun around and stomped my feet, humming to the tune of my own bodily energy, singing out from the absolute goodness of the feeling. I felt dizzy and I sank to the floor, sending most of the energy back to the earth.

It was time, so Ariel and I offered some of our meal to Selena and we ate the rest. We lay there, near the table, feeling full and happy. I stroked Ariel's soft coat of fur and she purred. When all was calm, we bid good night to the Goddess and ended the ritual.

I slept very well that night, a deep, entranced sleep. I dreamed I was swimming in the ocean, naked. The cool water felt so good, so refreshing against my skin. I tasted the salty water and felt its sting against my tender nipples. I was alone and I swam out very far from shore. It was nighttime and I could see the stars above and the big, round, smiling face of Mother Moon. All around me, her light was reflected in the waves of the sea, and the sparkling little lights of the stars were caught in every crest and valley of the constantly moving ocean. I watched the changing tapestry of lights around me, lost in wonder. Suddenly, I felt a soft touch on my hip and then the feel of a woman's breasts sliding up the

front of my body. Her head broke the water's surface and as I felt her nipples touch mine, I looked into her dark green eyes. She had very white skin and a mass of golden brown tangled hair. A coral necklace circled her throat and she wore pink pearls in her earlobes. She was beautiful. She put her arms around me and kissed my mouth. She tasted fresh and sweet, like a kiwi fruit. She held my arms pinned to my sides as she kissed me and as we sank beneath the waves. I shut my eyes when the water reached them and then, beneath the surface, I opened them in panic, afraid I was going to drown.

She spoke in my mind, telling me not to worry, that she'd given me the mermaid's kiss, so I was safe from drowning. I relaxed, and found I had no need for air. I smiled at her, and she said, "I want to love you." Her words glided into all the secret places of my mind and whispered hints of the pleasure she would give to me, if I would open up for her. I let my eyes travel over her body as she floated in front of me. I could see that she was a mermaid. Her womanly body extended to the middle of her hips and the rest was the shimmering golden brown tail the color of her hair. Her tail had the shape of a fish without the scales. It was more like the skin of a porpoise with a short downy coat of fur. She had ridged fins along her spine and shoulder blades, and very fine, sparkling webbing between her fingers. Her fingernails were long, slightly curved, and golden.

She read my answer as I thought it and pulled me into a loving embrace. I caressed her back and felt the strength of her fins as we kissed. I wrapped my legs around her body and we floated through the water as she kissed my mouth, my neck, my breasts. When she took my nipples into her mouth, I shivered and felt the electric tingle all the way to my toes. Her tongue was magical. My body tingled with pleasure as she teased me, kissing and licking all my tenderest places. Finally I could stand it no longer; I pulled her face

up to my lips again and kissed her face, loving her lips and eyes and cheeks. I moved downward, kissing her neck and breasts. I worshipped the beauty of her body and enjoyed the taste of her pointy little nipples. They changed from golden to bright pink as I nibbled and kissed and sucked them. I kissed a line down her belly, wondering what I would find when I got to the place I knew must be there. Her secret place was in front, right where I'd expected it to be. It was covered by a demure flap of skin which contracted upward as I approached, revealing a beautiful opening. It was pear-shaped, narrow at the top and full at the bottom. Lilac, pink, and golden shades blended together, highlighting a wonderful purple pearl at the top. I knew this must be exactly what it looked like, so I kissed it and heard my mermaid moan. I moaned too, enjoying her pleasure. I loved the taste of her pearl and the way she arched her back when I let my mouth and tongue play with her. I also loved it when she stopped me and told me it was her turn to play her lover's song on my body. I felt that I'd like this to go on forever, loving her and having her love me, as we swam through a multicolored forest of sea plants. But it lasted only until just before morning. She whispered softly in my head that it was time to part. "Thank you," she murmured, "you have loved me well." She kissed me one last time and told me, "You will find your true love at the sea." Then she faded away as I floated in the warmth of the water, which gradually became clouds, and finally only the memory of a dream.

I woke in the morning feeling refreshed and happy with the world and with myself. My dream seemed far away; but I remembered the last words she'd said to me. I wasn't altogether sure that it was more than a wish, but I decided to go to the beach for the day just in case. Ariel came in to

my room to tell me good morning and ask for breakfast. She said she was feeling really good, too. She was going to spend the day chasing butterflies and mice in the backyard.

I made us some eggs, plus a little cream for Ariel and some nice, hot coffee for me. After breakfast, I made myself a picnic lunch of a couple sandwiches and a banana. I put them in my day-pack along with a bottle of water. I let Ariel outside and made sure she had water, then took a shower.

In the shower, I thought, *I really do feel good. I think I'll wear my yellow swimsuit; I haven't worn that for a long time.*

I hadn't felt confident enough to wear it since I was much younger. It was so bright and so sleek, I usually felt too conspicuous when I wore it.

I got out of the shower, rubbed myself dry with a towel, and went in my room. I had to look in all my drawers, under my bed, and all through my closet before I found my yellow swimsuit stuffed up in a corner on the shelf in my closet. I put on the swimsuit; gathered a towel, shorts, and a shirt and some sunscreen; put them in the day-pack with the other stuff; and carried it all out to the car and threw it on the seat. I said goodbye to my home, locked it up (except for Ariel's special window), got in the car, and left for the beach.

I drove to Laguna; there was a lovely little lesbian beach there. It was in a sheltered spot with cliffs along both sides almost to the water's edge. A path led down a steep slope from the road. The path twisted its way alongside private homes and heavily planted gardens, full of ferns and flowers and trees. At the bottom, protected from the eyes of passers-by, lay a small, clean, sandy beach where lesbians felt free to sun and swim and hold hands and kiss. Once in a while a family wandered in, and quickly wandered out again. Sometimes a few gay men came to sun with lesbian friends, and this was okay. I found myself a nice, partly shaded spot

near one of the cliffs and close to the water, spread out my things, and sat to look around me. A Vietnamese man and his wife were fishing off the end of the cliff, apparently oblivious to all the lesbians nearby; and nobody seemed to mind. I watched the man catch a fish and reel it in. His wife took it from him and packed it away in a basket and they spoke to each other in their language. The wind blew their hair and shirts this way and that; and I noticed two small children playing among the rocks, close to their mother. They watched as the father handed the fish to the mother, then turned their attention back on each other and the rocks, sand, and little sea treasures around them. I wondered if they knew we were lesbians here or if they just thought we were all very good friends. I rubbed sunscreen on my body and lay back on the sand, to soak up the sun and let my mind wander where it would.

The heat of the sun entered my body, soaking through my skin and deep into my muscles and bones ... so good, so hot. I relaxed and a delicious thrill of heat tickled up my spine, starting on the very tip of my tailbone and traveling slowly, almost erotically, up to my neck. I smiled.

"Well, now," a deep, rich, female voice said, "what kind of thought puts a smile like that on your lips?"

I opened my eyes, still feeling lazy and hot, and I saw a very tall, very dark African-American woman looking down at me. Her silvery black hair was short, cut close all over her head. She smiled at me and one of her teeth was rimmed in gold. The gold caught the sun and flashed at me, startling me; I sat up and she laughed.

"I see I caught you," she said. "I tried to catch you at the picnic, but you slipped away. A neat trick, you have; the first invisible woman I've ever met." She sat down on the sand next to me. "I'm not going to ask if it's okay for me to join you. I'm sure you would rather be invisible again. But I've

caught you smiling in the sun, and you have to stay a bit now and talk to me."

"Hello," I said. I didn't know what else to say. I didn't really know what she was talking about, except it seemed, somewhere, to make sense; and she so obviously believed in what she was saying, that I didn't have the nerve to contradict her. Besides, she was so big, so black, her smile so sure, and there was that bit of flashy gold; I was quite overwhelmed. I liked her, too. She looked magnificent. I smiled at her. "My name is Linda," I said.

"I don't doubt that!" She laughed. "You can call me Maxie, for now," she said. She gave me the most confusing feelings. She was right there, and I felt both uncomfortable and happy to be next to her, so much energy, so much beauty; yes, I guess she was beautiful, with her deep, smooth, gorgeous brown skin, like a Hershey bar, beautiful. A big, chocolate kiss of a woman. And yet, with her flashy gold smile, direct look, ageless face, and sparks of energy just shooting out of her, I also felt distinctly uneasy and wanted to get away from her.

"Maxie, where did you come from?" I asked her. I almost expected her to say, Mars.

"Right here, Linda; I've been here at the beach for an hour, watching the women. I saw you come, I watched you settle against the sand. I knew you were the invisible woman from the picnic, but something has taken away your cover, girl; you are here in the world and we can all see you now. So I came over to see if you would disappear or not." She smiled her flashy smile at me. "And I caught you making love to the sun!" She lay down next to me, so I lay down too. "Give me your hand, girl. Let's make love to the sun, together. I want to feel the way your smile said you felt."

I lay there, next to her, holding hands. I decided to trust her, and closed my eyes. I let my body relax. I felt the sun

again enter my body. I also, at the same time, felt the energy from Maxie, first from her hand, then from her whole body alongside mine. The sun's heat from above, and Maxie's from the side, warmed me. I tingled. My nipples tingled. My lips tingled. My spine again felt the sun, playing my bones, my ligaments, my nerves... All of my body started to hum. It was very erotic. The side of me next to Maxie reached out, and, without touching, I felt the velvet smoothness of her skin. My nipples reached out to her and brushed her nipples, though I never moved at all. My lips somehow kissed her, as we still lay there, not touching. My whole body rubbed all over hers, and the sun caressed us as we lay there, not touching. We throbbed in orgasm, together with the sun.

She opened her eyes, and she looked dazed. "Thank you," she said, "for fucking the sun with me." We smiled at each other, and went to sleep. It was a good sleep, deep and dreamless. I woke up feeling good, happy and relaxed. I turned to smile at Maxie.

She was gone. I sat up. I looked around me, at the other women scattered about the beach. The Vietnamese family was gone. Maxie was nowhere to be seen. I looked down, at my body. *Maybe it never happened,* I thought. Then I saw something on the sand where Maxie had lain. It was a bit of seashell, used as a paperweight to hold down a piece of paper.

I picked it up and looked at it. It was a picture of a unicorn. A shimmering opalescent unicorn, against a vibrant blue sky filled with shining silver stars. I stared at the lovely colors and shapes on the card for a moment, enthralled. Then I turned it over. There was a phone number on the back. "I believe in Magic" was written above the phone number. *Well,* I thought, *so what does that mean?* I guessed the next step was up to me; the Goddess had given me the choice and my destiny was in my own hands. I felt, all at

once, a sense of relief. I also felt kind of disappointed. I wanted both: I wanted to be free, to choose for myself whether to become entangled in the web of love or fly away, on my own. But I also wanted to be lazy, not to decide anything; to have another, stronger woman decide that for me. To sweep me off my feet, into totally irresponsible and passionate love. *It seems,* I told myself, *that Maxie does not want that responsibility and, after one delicious afternoon, a mere taste of what could be, has thrown the decision back to me.*

I put the card in my day-pack and ate my lunch. I thought about Bonnie, and what she would say to me. I knew she would push me to call Maxie that very same night. I thought of my other friend, Ariel. She would counsel caution; she would want me to consider all the possible changes a lover would bring into my life (and hers as well). She'd want to look Maxie over. I smiled at that, imagined telling Maxie that my cat had to approve of her before we could become involved. What would she say to that? I finished eating, and gathered up all my things The sun still warmed me as I walked away from the sea to go home. I decided to call Maxie that night. I wondered if moonlight would feel as good with Maxie as sunlight had. Maybe it would be even better. After all, moonlight, and magic, came from the Goddess.

Alayne Gelfand

The Garden

T he domes were cracked and gaping. Weather had eased her way inside, depositing rain and snow alike, leaving trails of seedlings and young trees, flowers, and wild berry bushes in her wake. Life oozed through the overgrown grass, slithering among the roots, beetling along spiderwebs. The smell was a heady mix of mildew and sweet pollen, a perfume that spoke of "outside," of the forbidden. Of the Before Time.

Trinity lay on her back, blanketed by a fresh fall of sycamore leaves. They tickled her bare skin and she smiled up through the holes in the dome roof at the ice-cream-blue sky, laughing at the exquisite feel of sun on her face, of growing things caressing her body. But, above all, it was the mere danger of being here, of disobeying one of the Prime Rules and venturing beyond the compound alone, that made her feel wicked and sultry.

She'd once brought Cree with her, wanting to share her special place with her best friend and intended mate, but the other girl had been afraid the entire time, glancing over her shoulder, expecting a guardian to appear over the horizon at any second. It had been a long, tiring day. A disappointing day. A day never repeated.

The ruins were off limits, located in the forbidden wilds beyond the woods. Everyone knew that. Everyone knew that *they* lived here, the mutant creatures with no language and features made of stone, misshapen bodies covered in moss and filth.

Everyone knew that this was a place of the Before Time, before God had made her ultimate adjustment to life and given the Secret to the Prophet Janna. The Secret of Life, of reproduction through potions and magicks known only to a few of the old ones, and the Priestesses. The domes were a bad place. It was written.

But Trinity had always been suspicious of anything that was "written" but couldn't be read. There were no books, no scrolls, no stone carvings stating the Word of Janna. The only solid proof of the Secret was the miraculous evidence of the Evani reproducing themselves in the form of new, healthy infants. But the heart of the legend of the Prophet Janna was in the stories of the old matrons, handed down from mother to daughter to granddaughter and so on. And those stories had become Law and Law had bred fear and fear kept the Evani well within their compounds and all but Trinity away from the dome ruins.

A tiny bird, no larger than the palm of her hand, fluttering rapidly above Trinity's face brought her attention back to her surroundings. She smiled up at the tiny creature, watching as it flew to a blood-red flower and settled over a blossom. How anyone could consider this place evil was beyond Trinity's comprehension. Only beauty grew here. Only beautiful things happened here. Like that day she had brought Cree with her. For a while, she'd managed to distract the other girl's fear with her touch. A kiss was as good as a drug to Cree and Trinity's kiss was better still.

The long bronzed body of her lover basked before her in her mind and Trinity stretched her limbs into the thick grass,

rubbing her naked back in the cool earth. She remembered how smooth Cree's skin had felt in the noon air, how Cree's flat belly had given slightly beneath her fingers, how the coarseness of the hair between Cree's hard brown thighs had scratched and tickled her cheek as she rubbed herself the length of Cree's willing body. The smell of her lover aroused was very near the scent of the moist earth where she now lay, musky and real.

Trinity rolled onto her stomach, burying her nose in the moist grass, in the memory scent of her lover's moist aroma. She groaned in delight as blades of grass probed her pores, stabbed sharply into the delicacy of her bare skin, the tenderness of thigh, the vulnerability of breasts. She wiggled farther into the earth as her mind recalled making love to Cree. How wanton they'd been beneath the ancient dome, how craven their pleasure as Trinity buried her tongue deep between Cree's parted thighs and lapped at her eagerness, drawing her lover's desire deep into herself.

Until that day, until she'd talked her intended mate into running away from the compound, they'd had only long nights of rest in each other's arms and hidden moments of pleasure, quick gropings secreted from the ever-vigilant eyes of the guardians. If they knew that she and Cree shared loves... The result wasn't worth thinking about. Not now, not when she could so easily bring that lovely day back to reality by the touch of her own hands on her body, echoing Cree's touch, reminding her own flesh of how sweet their loving had been.

Trinity couldn't take enough of her lover's excitement into herself, the scent was so overpowering, the taste so sweet. When Cree's hands had urged her to turn, she'd done so with little thought, she'd been so absorbed in giving her lover pleasure. The touch of Cree's tongue to the inflamed flesh between her thighs caused Trinity to cry out to the surround-

ing wilderness. She felt completely open, exposed and cherished as Cree continued her labial probing, adding the touch of her long golden fingers to Trinity's swollen desire. They bucked against each other, trying to draw each sensation out to its fullest, both girls feeling free and expansive, knowing this rare opportunity at abandon should be close held and made special.

When it all became too much and Trinity knew that she would either climax or perish—perhaps both—she relaxed backward against Cree's face, letting her lover probe deeply, letting her lover bring her over the top of the incline and into a horizonless valley beyond. She shuddered and chilled as she came, biting into the soft flesh of Cree's thigh as she did, letting the waves of pleasure roar over her, soak into her flesh, moaning her gratitude and love all the while. And when she could think clearly, she turned her face back to her task of bringing her lover along with her.

They had lain together, arms wrapped tightly around one another, for long moments. Then Cree's nervousness had returned and Trinity had finally given in and allowed her lover to drag her back to the compound, promising at Cree's insistence that she'd never return to the dome ruins again.

She smiled to herself as she rolled again onto her back, her heavy golden hair falling over her face, obscuring her view as she gazed up through the holes in the dome overhead. It was an addiction, this place, this feeling of freedom. Nowhere else was she without some kind of pressure to be a certain way, to behave properly, to show respect and propriety at all times. Here, in this ruin from another time, she was able to be herself, abandoned of constraint, apart from convention.

A gentle breeze had picked up, causing a distant song to peek around the fragments of broken dome; a lovely whistle on the wind. The song had come that day too, as she and

Cree had rested after loving. Memory was sharp and clear and her body longed for her lover's touch, longed for those strong brown hands to bring her through the valleys of sensuality she was walking and into the boundless meadow of release.

Wickedness and desire spurring her on, Trinity let her legs fall open, drew her knees up so that the moist flesh between her thighs could catch a bit of the musical breeze. The touch of cool air was delightful and she felt herself flood at the caress. Biting her lower lip, she let her hands rest on the swell of each breast. She'd grown larger over the past season, turning from a budding girl into a woman. It was only a matter of time until she bled. Then she and her lover would unite. Then the hands molding her breasts would be Cree's, not her own.

Her nipples grew deliciously hard, ripe beneath her own fingertips, and she squeezed just past the point of pain, gasping as the sensation raced from her breasts to her groin. She pinched one more time in parting and let her hands wander over her solid abdomen, down the womanly swells to the thatch of fur between her legs. She only touched the hair at first, teasing herself, feeling her own moisture seep outward. Again, she gasped at the sharp sensations.

Her fingers tracked the inside of her thighs, tickling, massaging the strong muscles, pulling gently at the hair at the top. Then, slowly, she let one finger touch the swollen moistness between her legs, let the finger dip into the recesses and draw forth more wetness. Another finger fol-lowed, her free hand rubbing up and down the inside of her thigh, over the hip to the fold of flesh between leg and buttock.

The breeze still caressed her skin and she opened her legs farther, trying to draw the cool wind inside, holding herself open with her fingers to welcome the breeze. She arched her

back, thrusting her breasts into the air so that they too could partake of the coolness around her. And it was in that moment of feeling completely open to nature and her surroundings that she first felt it.

She was being watched.

The thought flashed through Trinity's hazy mind and she knew she ought to be on guard, alert for some wild animal or, worse, a guardian. But she somehow knew it was no animal and certainly no guardian from the compound that now watched her self-indulgence. She felt no threat though, no danger. Maybe it was just the ancient spirits come to celebrate fulfillment along with her. She continued caressing her clitoris as she opened her eyes and looked around. Nothing seemed changed: the trees and flowers were undisturbed; the door to the huge dome remained braced as she'd left it. Yet the eerie feeling remained: she *was* being watched. Curiosity made her sit up, her hand not stilling in its business of keeping the fluids flowing between her legs. She turned to look over her shoulder, only to find everything as it should be. She was just about to lie back down, spreading her knees wide in preparation, when she heard the noise. It was just a rustle of bushes but it was a sound only an Evani could make: footsteps on dried leaves.

Trinity froze, half sitting, half leaning on one hand, her other hand buried between her thighs. The sound came again, and she turned to her left, slowly scanning the foliage for the source of the sound. Her heart beat loudly in her ears and, to her amazement, the flesh beneath her fingers grew hotter and wetter. Danger had always excited the adult woman in her.

When the creature stepped into the open, Trinity's first thought was that either all the legends were wrong or this was simply a young one, an underdeveloped youth. The thing stood a head above Trinity's own height and rested

squarely on two strong, pale legs. The chest, abdomen, and legs were lightly furred, as was the face, and hair grew from its head in soft chestnut-colored waves. It wasn't ugly to look upon. Only strange, considering that it had flat breasts and an odd-looking protuberance between its legs. The fleshy limb stood at an angle from the groin and was supported by a swollen sac beneath. It looked angry to Trinity and she wondered if the thing had injured itself.

The creature blinked at Trinity, one hand reaching for the ugly wounded flesh between its hairy thighs. Then it smiled. It was a shy, hesitant smile, but it most definitely was a smile.

Trinity nodded at the creature and smiled back, holding up her free hand in welcome, indicating it should sit down if it wanted. She felt a thrill as the lanky form moved forward, holding the swollen thing in its hand, rubbing at the angry-looking tip. It moaned softly as it settled near her and finally tore its leaf-green eyes from her face, its gaze settling on the hand that was still probing between her legs.

Knowing this was one of *them,* one of the mutant beings without language—the creatures that were spoken of in whispers to small Evani in order to scare them away from forbidden places—made Trinity's heart beat even faster. Not only was she breaking Prime Rules at the moment, she was actually sitting in a dome ruin, touching herself to arousal, beneath the gaze of a mythical animal.

But she saw that this was no beast. The expression on the almost-beautiful face was one of intelligence and compassion. There was pain and desire in those soft green eyes and gentleness in the hand that touched the creature's protruding flesh. Without thought, Trinity saw her free hand move forward, saw her fingers brush the purpled tip of the swollen limb, and was not too surprised when a loud groan left the long, hairy throat. The green eyes had widened and the face had tensed at her touch. But it did not pull away from her;

in fact, it moved slightly nearer as though inviting her to touch again.

And she did. She touched the tip of the limb again and found it nearly as wet as her own flesh, saw that the sensation her touch relayed was perhaps something like that which it relayed to herself: the creature's eyes shut and its head fell backward in trust. Trinity's heart expanded in empathy for both the creature's desire and its pleasure.

Knowing there was no immediate danger from this lovely being, she moved closer, spreading her legs on either side of the creature's hips so that the engorged organ nearly touched her clitoris. The mere thought of it, of being touched by something so alien, so hard, so big, made her genitals clench with desire. And seized by the base urge, she wanted to thrust herself into the large body, hold it against her own and rub against it. But more than that, she wanted to take that strange protuberance and place it against the sacred entrance to her body, the place where she would one day bleed, the place that belonged only to Cree.

Trinity glanced up from her perusal of the organ she now held in her palm to see the creature's eyes rooted to hers. And she realized that she couldn't keep thinking of it as an it, as having no soul, no mind. This was not an Evani, certainly, but it wasn't an animal, either.

Almost afraid to break some magical spell, Trinity hesitated to speak, distracting her mind once again with the touch of hot, swollen flesh in one hand and her own moist flesh pressing against her other. But she was determined to see if any more of the legend was wrong: if the creature was not so ugly as was "written," maybe the part of the legend that told of no language was wrong too.

"I am Trinity," she said, her voice soft and careful.

His eyes widened in surprise. "Trinity?" a gruff, deep voice echoed back. "You speak."

Trinity smiled at his surprise. "As do you. What shall I call you?"

"Tennyson," it responded. "I am Adaman."

"I am Evani," Trinity returned, mind spinning in many different directions as parts of ancient legends fell into dust at their feet. This was no creature, this was no evil spirit that haunted the ruins and ate young Evani for dinner. This was a gentle, living being. This was an Adaman, something other than Evani, but seeming very much the same.

"Tennyson," Trinity began, "does it pain you?"

He looked puzzled, then smiled as Trinity indicated the Adaman flesh she still held. "It is for pleasure," Tennyson told her, a blush creeping across both cheeks and down its neck. "Pleasure between mates," Tennyson added shyly.

Trinity nodded. "As is this," she said, holding the folds of her nether lips open for Tennyson to see. "But you saw that I take pleasure alone, didn't you?"

Tennyson nodded. "And seeing that made me want to do the same."

Trinity nodded, the desire to be touched by Tennyson's mating limb returning stronger than before. She smiled crookedly, looking at Tennyson from beneath lowered brows. "Punishment is great for breaking rules of pleasure," she stated.

Tennyson's mouth quirked back at her. "Yes."

Decided, Trinity turned all her attention to the flesh she held. It was warm, hotter than Tennyson's leg she discovered as she touched his thigh with the hand she removed from between her own legs. She liked the way the moisture from her own fingers made lacy lines on Tennyson's pale skin, matting down the soft hair there. Her touch made the organ bob against her palm and she laughed in delight, slapping Tennyson's hand away when it moved to touch the swollen sac beneath the limb. She touched there herself, finding two

hard balls swimming within the soft skin sacs. She let her fingers play with the hardnesses, jiggling them and squeezing, backing off when Tennyson gasped, knowing she had caused pain. In apology, Trinity ran her hand up Tennyson's stomach to the two flat nipples on its chest.

"Do these grow?" she asked.

Tennyson laughed. "No."

"How do you feed your reproductions?"

Tennyson frowned, then the green eyes widened in understanding. "The healers give one mate a potion and these"—Tennyson touched his nipples—"do grow. A little. Milk is made then. The small one feeds here until he is able to walk. Then he eats as we eat."

"'He'?" Trinity questioned, still examining the nipple, disbelieving that it could produce the same fluids as her own.

"Adaman are he. Are you not he?"

Trinity shook her head. "I am she," she whispered, something in her mind feeling itchy, as though knowledge was trying to speak her name.

"'She,'" Tennyson repeated. "Trinity is she."

"Evani is she," Trinity corrected, noticing how the nipple beneath her finger hardened at her touch just as her own or Cree's might.

Tennyson shivered as Trinity pinched one hardened nipple, his hand moving to cover her fingers.

The touch was like nothing either had felt before; it was as though lightning had come down from the skies to kiss their bones. Each stared at the other, and Trinity felt a surge of doubt. She wasn't sure just how wrong her thoughts were but she knew they *were* wrong. To even consider sharing love with someone other than Cree, let alone an Adaman, a legendary creature of evil and horror.

But Tennyson's touch was warm, sweet, and the hard flesh between his legs looked so desirable as it moved with

his heartbeat in her hand. And it would be far from the first time Trinity did something against the Rules.

Shyly, Trinity glanced into Tennyson's eyes and saw the same wickedness that echoed within her own heart reflected in his leaf-green gaze. She smiled. And moved forward ever so slightly, only the small distance needed to bring Tennyson's third limb within easy reach of the rainy folds of flesh that throbbed needfully between her legs. Looking down, she watched her thighs spread farther as though of their own will, watched as Tennyson's hips tensed, bringing the very tip of his moist limb into electric contact with her vulva.

Trinity gasped and jerked her hips backward at the same time, automatically removing all contact with the horribly wonderful object that protruded from Tennyson's groin like a lightning rod. Remembering to breathe, Trinity shrugged both to herself and in apology to Tennyson, and scooted back into the embrace of his strong thighs. She nodded again, bracing herself on both arms and closing her eyes in preparation for the nearly overwhelming sensation to be repeated.

This time when Tennyson's limb touched her flesh, Trinity managed to remain where she was, but her breath left her again and her entire body surged forward as though begging for more of the feel of Tennyson against her. Some part of her mind heard his gasps of pleasure, but she was too occupied with the previously unimaginable feelings pouring through her abdomen and storming her breasts, arms, legs, and mind to register that the same feelings seemed to be echoing in the body of the forbidden, mysterious, mythical Adaman in her arms. All she was aware of were the thunderclaps in her ears, the torrent of rain drenching her thighs as her womanhood wept with pleasure, the staticky pulses stinging her blood and sparking behind her eyes until she felt faint and euphoric and terribly evil all at once.

Then Tennyson moved. His limb rubbed inward and upward, moving slickly over her swollen flesh, smearing their fluids into one viscous entity, causing Trinity's arms to buckle beneath her weight. She fell backward into the tall, cool grass, becoming hopelessly entangled. She writhed into the wet, cunt-smelling grass, drawing her knees upward toward her breasts, rocking her pelvis slightly to encourage new and more exciting angles for Tennyson's limb to rub and probe.

He moved with her, leaning over her body as it splayed itself into the grass, pushing down with her as she tried to plant her body into the rich earth beneath her sweating back, moving into her as her legs spread and the sharp-scented folds between her thighs opened even farther, beckoning him to enter, drawing his limb inward as though her vagina was possessed of some magnetic force all its own. A deep, guttural moan escaped Tennyson's hair-encased lips as the long, hard, wide limb spread Trinity's nether lips farther apart, as he pressed through the clenching muscular tissue into the soft, salty ocean of Trinity's virgin womb.

Trinity screamed. There was a ripping sensation that was something like pain but also nothing like it. Then there was a burning, as though a cut had been rubbed with tanning solution. And then there was just a gentle soreness buried deep within the heart of her womb, so deep the feeling seemed to be coming from her bones, echoing from her soul. A shock ran through her limbs, traveled into her chest, and surged first toward her rock-hard nipples, then downward to her genitals, where it gathered and built upon itself, seeming to perch on the edge of some unspeakable cavern, just waiting there like a bird watching for prey.

Tennyson's face had drawn tight at Trinity's cry of pain; his body had grown still and rigid, the flesh now probing her soul softened slightly. But as Trinity assimilated the fullness,

the throbbing caused by the mysterious limb buried in her gut, as Trinity smiled at him, Tennyson's body responded by growing harder again and beginning to move in a smooth, slow, unbearably beautiful rhythm.

In. Out. In. Out...

The pattern repeated as steadily as the drum at a Joining ceremony. Trinity started humming along with the beat until she found the steadiness beginning to cause a loss of sensation inside her. Not wanting to lose the beauty she felt surging through her, she thrust her hips upward, hard, just as Tennyson's hips were on the down stroke, causing them to meet belly-to-belly, causing Tennyson's eyes to grow wide and his hips to buck in an arrhythmic counterpoint to the song they'd been singing. They smiled at each other and continued to interrupt their own chant, creating new music, new harmonies and counterharmonies, until Trinity felt some huge finale approaching. The feeling was not unlike what she felt when Cree would nibble at her sex until she'd nearly black out. A similar sensation, but far beyond and above anything she'd felt before.

She knew, even as her legs tightened around Tennyson's back, even as she felt his limb bump erratically against the walls of her womb, that at least part of the extraordinary sensations were wrapped up in the illicitness of it all, in the taste of forbidden fruit. But it didn't matter. Not as his hips thrust into her pelvis one final time and his entire body became taut and strung tight as his limb pumped vaguely hot, distantly sticky fluid into her body. He remained drawn tense like that for long moments while Trinity held him firmly against herself, while she pressed her clitoris against his pelvic bone, while she pushed herself over the building tide into a river of blessedly consuming climax.

Blood swept through Trinity's ears, blacked her vision, made her arms and legs vibrate with its speed. Her womb

clenched around Tennyson's softening limb as though for-
bidding it permission to withdraw. Moisture flooded the
insides of her thighs and Trinity knew it was not solely her
own fluids soaking into the ground beneath them. Her body
shook and shuddered as wave after wave tossed her about
like flotsam upon the tides within her own body. Breath fell
from her in great gasps and a chill settled over her breasts,
causing the nipples to peak almost painfully now.

The warm weight of Tennyson's body collapsed over hers
was alien, nothing like the soft, sweet, delicate lightness of
Cree's sleep-encrusted body late at night. There was no
petting, no shared kisses, no whispered words of love and
commitment and loyalty. There was only the hot, hairy
sweetness of Tennyson's still-heaving chest, the stickiness of
his withered limb as it snuck from within the cradle of
Trinity's body. And the strange, almost animal scent of mixed
fluids.

Trinity found her eyes focused on the bird's-egg-blue sky
peeking in through the ruined ceiling of the dome, found her
thoughts focused on Cree and what she might be doing as
the day wore on and there was no sign of her intended mate
in the compound. She fixed her thoughts on the beautiful,
honey color of Cree's skin, the clear-lake tone of her pale
eyes, the willow-bark-brown of Cree's close-cropped hair.
She thought of Cree's scent and the taste of her lover's
womanhood fresh and spent on her tongue. She felt love rise
in her chest and try to choke her as she also drew in
Tennyson's musk.

Body grown cold and hard, Trinity simply lay still as
Tennyson's bulk was slowly withdrawn. She didn't look up
when he spoke, didn't respond to his muttered words of
apology and responsibility. Some part of her mind heard his
words and was even grateful for his generosity, realizing that
compassion was present in full force in this strange creature

of myth and mist. But she let that realization sink deep inside her where she could retrieve it later. Much later. After she'd cleaned herself of mingled fluids and sweat, washed the rich, black earth from her golden hair, and returned to the safe familiarity of the compound. Then she'd think about the nonpersonal implications of her encounter with Tennyson. Then, when she was nestled deep within Cree's toasted arms, she would consider how she would tell the others about the mysterious creatures who also visited the domes. And of the disturbing pleasure to be found in their arms.

Raven Kaldera

Flying Dreams

Deseret awoke with her heart pounding, a scream nearly escaping her lips. It took a few disoriented seconds to make out the plain beige walls of the spartan dormitory room, to hear the breathing of her roommates in their beds. She sat up in bed, wrapping the blankets around her thin legs and shivering in spite of the too-warm room. Everything was too warm on CYU; the climate control was always set at a higher temperature than she was used to at home. Most of the students were Earthers, "hothouse Earth" as Janine in her Geo class joked, and were used to higher temperatures. Deseret deliberately slowed her breathing and waited for the derms in her temple underwear to turn on a mild sedative. When it didn't come, she realized why with a sinking heart. She'd had nightmares every night for a week now; the garment was programmed to consider this the sign of a guilty conscience and was withholding the sedative in order that she might pray and discover their source.

She sat forlornly with her head on her drawn-up knees for a few minutes longer, hoping to stall the inevitable, and then, sighing, got out of bed with the blanket still wrapped around her and knelt beside her bed. Fighting to keep her breathing slow and even so as to reach the proper state, her

lips moved soundlessly in the opening prayers. By the time she got through them, the nightmare was like a vague image in the distance, something about pain and longing and blowing curtains of scarlet and purple and blue-violet, all the colors of blood. Was it a bad omen? She couldn't remember enough of it to tell. *Please, O Lord, deliver me from this evil,* she prayed desperately. *Deliver me from the impurity in my mind, from the sin in my soul.*

After an hour of kneeling on the hard floor until her legs ached, she slipped back into her bed, exhausted enough not to need the sedative. *I had better get over this before Elder Nephi notices the readings my temple garment is processing and sends me back home for help,* she thought to herself, clutching the sheets around her in dismay at the thought. It was an honor to be chosen to go to CYU. Few girls on her home asteroid of Adam-Ondi-Amen were, and few Adamians left their home. With what she was learning here she could help her people at home, help upgrade the failing systems and life support, the increasingly infertile hydroponics, the outdated medical techniques. It was a mission of life and death, Elder Graves had told the young students as they sat in a taut, excited row, all dressed alike in their white jumpsuits. We all depend on you.

I hope I won't be too tired tomorrow in class, she thought sleepily as her eyes sank shut. She had been bleary-eyed in too many classes lately. However, she had the nagging feeling that her praying tonight had been in vain, at best only an aid to exhaustion. She had not been able to bring herself to actually think about the catalyst that had started the nightmares, had not been able to speak the name of the presence she wanted—and did not want—to purge. Now, on the very edge of sleep, she said it twice. "Neidra," she whispered. "Neidra."

"Bhaktipan women always smile like this," Neidra laughed, and struck a pose with glassy eyes and a curved, blasé Mona Lisa smile of patience. "As if they're all really saying, Why do I have to put up with this asshole I'm married to? Look at all the pictures, even from Earth India thousands of years ago. You'll see that same smile." The dark almond eyes in her perfect, heart-shaped, olive-skinned face twinkled, and her smile morphed into a mischievous grin. She wasn't smiling at Deseret, wasn't even looking at her; Neidra's attention was all on the other half-dozen students crowded around her, and Deseret was actually glad of that. Not just because Adamians had strict orders not to fraternize with the other students except to witness to them, either. Her heart was pounding and her palms damp just being five feet away.

Then leave, she tried to tell herself sternly, but her feet somehow refused to move. She kept watching Neidra, her slightly plump, full-breasted figure, her tiny delicate hands adorned with multiple silver bangles, the great cloud of fluffy black hair to her waist. What must it be like to touch that hair, to brush it smooth? It must be coarser than her own limp, mousy hair, but much thicker. *It wouldn't be a sin to enjoy the feeling of brushing Neidra's hair,* she pleaded with herself. It would be just like sisters, the sister she never had. Wouldn't it?

Danila was talking now, discussing some point in her last class. *His,* Deseret reminded herself fiercely. No matter how pretty and feminine Danila might look, he was a spawn of Satan, a walking sin. He had been born male, and no body change could alter that, according to Adamian doctrine. If Deseret could have named a single thing that had horrified her the most, had been the greatest source of culture shock upon coming to CYUniversity, it would have to be the nachtlei from Karanda, the third-sex people with their

strange names for themselves, their bright, flamboyant clothing, and their utter lack of sexual prudery. It wasn't just the androgynous ones, where you couldn't tell what they were. It was the ones who looked perfectly normal but had once been something else. It unnerved her completely. She couldn't even bring herself to look Danila in the eye.

She noticed one thing about Danila, though. Her hands. Large, beringed hands with long glittery nails. Too big for a woman's, but not like a man's. And one of them was slipping gently, flirtatiously into Neidra's tiny brown one.

Deseret turned away from the group, hugging the book-pad to her, and went down the hall, sick to her stomach. She tried to tell herself that the overwhelming feeling of wrong-ness that she felt was her horror at the idea of that perverted creature touching anyone, especially sweet, laughing Neidra. But the more she examined the emotion from the corner of her eye, the more she realized that it was just seething jealousy, plain and simple. The realization made her even sicker.

Her roommate Emma caught up with her at the end of the hall, "I have bad news," she whispered. "Elder Nephi is going to speak to you on Friday, before services. I heard him talking over the com while I was downloading the morning prayers onto the pads. Some thing about your monitoring. What did you do?" At Deseret's frightened white face, she glanced around and continued in a falsely compassionate voice, "You can tell me. It's all right. We're friends, remember?"

"I—I don't know," Deseret stammered. "I haven't done anything. I go to class, I..." She trailed off. Could the temple underwear that she had been sealed into at the age of twelve, impregnated with its monitors to check her heart rate and blood pressure and general health, to help her sleep and make sure no mind-altering substances went into her blood, could it have sensed something? And what?

One thing was sure. As of Friday, she was doomed.

"Feels nice, dear, doesn't it? Neidra's very good at what she does." Professor Chemarin stroked Danila's hair as Neidra's tiny but capable hands dug into her back, banishing the sharp crystalline knots of lactic acid. Prostrate on the neosilk bedsheets, Danila could only moan with pleasure, a sleepy smile on her face.

"This won't affect my grades, will it?" she mumbled from the depths of the pillow. Danila knew there was probably something in the CYU rules that disapproved of ending up in a threesome with a classmate and your parapsych prof, but she had had a crush on both pretty Neidra and the tall, brilliant, chocolate-skinned professor since coming here. It was like a dream come true, especially for a nachtlei like herself, who found it hard enough to get lovers. Neidra finished the massage and began to kiss the back of her neck, kisses moving slowly down her spine until her tongue flicked into the crack of Danila's ass, making her forget all about grades. Neidra laughed softly and her tongue flicked deeper, worming its way into Danila's asshole. The nachtlei girl moaned and thrust her ass up, letting Neidra wrap her arms around her hips. She was vaguely aware of Professor Chemarin ("Call me Bess," the older woman had said, but Danila was too intimidated) brushing the hair away from the back of her neck, setting her mouth to it in a teasing kiss.

"So you've been having dreams, have you?" came the smooth voice in her ear. Neidra had her up on her knees now, and she could feel that hot mouth moving down to her genitals. It was impossible to concentrate on what the professor was saying, but it was something along the lines of "I can help to show you what they mean. Just relax and let go."

The older woman had her by the hair now, in what seemed to be an iron grip, turning her head to the side. She caught a glimpse of one dark purple-tipped breast showing through the neosilk kimono, and then that full mouth was on her neck again. She was suddenly, painfully aware of the lines of energy running through her body like currents, like golden rivers flowing in and out. Mostly flowing downward now, toward the place where Neidra, now on her back with her head between Danila's thighs, was coaxing such pleasure out of her. Then Professor Chemarin got her teeth into the muscle of Danila's neck and sucked.

It was like agony and ecstasy. The streams of golden energy were forcibly pulled upward, rushing from her groin to her throat and ... outward? The oral sex went on and on, and she was kept at the very edge of orgasm, unable to come, until that cruel mouth released her throat and she swooned into an orgasm fiercer than anything she had ever experienced. She seemed to be at once in herself and Neidra, to feel both her own peak of pleasure and Neidra's wet hunger and elation at having made Danila buck and thrust like an animal in rut. And there was more ... stars, asteroids, planets, whirling clouds of space dust, a thousand minds of the population of CYU, some open to her and some not. The professor was a curious blankness in all of this, a place barred to her. As the sensations faded, she curled up into herself, wondering, her head in Professor Chemarin's lap. It was a safe haven, a breathing space, a place where she could think her own thoughts and no one, no one could intrude upon them.

Danila felt Neidra's warmth against her back. "You'll be all right," she whispered. "It was a little weird for me too at first, being fed on. But pretty soon you'll have everything under control." And she spoke a Word, a word no one else but Danila could know, a word that had no meaning, and

yet meant everything, safety and love and an outpouring of acceptance, that had been within her as long as she could remember, that had sustained her through her change.

"How did you know about that?" the nachtlei whispered.

"It's simple." The professor's rich accented voice sounded above them, as if from a far distance. "I met both of you long ago, when you were children. You and many more. You were special, gifted. I gave you that Word, and it brought you here. To the Dream."

"The Dream?" Danila was ready to believe anything at that moment, even this.

Neidra laughed. "I'll show you," she said, and pressed her fingers to Danila's temples.

"It's hardly my fault. I couldn't have accounted for those horrible suits they wear." An antique letter opener shaped like a sword was stabbed viciously into the resin desktop through a pile of papers. It stayed upright, like a cross-shaped grave marker. "I'll have to get this desk refinished someday," its owner mused. "Anyway, they hadn't started using the awful things the last time I was there."

"When was that?" asked the visitor, a nondescript man whom no one would ever notice in a crowd, whose features no one would be able to recall if they saw him alone. There was something almost unnerving about his nondescriptness. "A dozen years ago? You've had time to check their new practices and make allowances for the suits, and the dermal hormone blockers. I hear the Elders are going to have intracranial implants soon."

"Then that will dry up any chance we have of recruiting from AOA," came the sharp, decisive voice. "As it is, it's not my job to keep tabs on all these things. I have enough to do. The question is, what do we do with her now?"

"She is receiving the dreams, isn't she? Won't they just take their course?"

An irritated sigh. "You don't understand. Those dreams are keyed into the sexual responses. That's how we reroute the awakening energy, so it doesn't come out in ... other ways."

"You mean like that girl who set her window curtains on fire. Yes, I heard about that."

"That was in the early days, when the Aquila Circle had too many prudes in it. When you're cracking open a teen-ager, sexual energy is the best bleed-off. Since we've insti-tuted my program, there've been no problems."

"Until now," the visitor said sourly.

"Until now. The poor child's libido is repressed entirely by the dermal chemicals in that suit. All Adamians' are. Nice and sexless and celibate until they're married off. You know, they aren't even allowed to masturbate. I wonder if they're going to start artificial insemination soon so as to remove a need for sex altogether. At any rate, without that outlet, the Aquila Dream comes across as a nightmare. Poor little thing."

"We could give up, send her away," remarked the man. "Off CYU, she'd be out of range for the Dreams. It'd be an easy thing; they're all so paranoid. One remark to that Elder about her performance slipping and she'll be home in a week."

"Where she'll probably go mad. Once you crack 'em, most stay cracked. It's a rare new psi who can get shields up by themselves, figure out what's going on without help."

"You did," the man reminded.

An amused chuckle. "Yes, but we all know what I am, don't we? No, this girl is a Sensitive, no psivamp. She'll end up in a padded room, or worse. The only thing I can think of is to have her quietly disappear."

"That's insane! There'd be nothing quiet about it! The Adamians would raise a holy stink the size of a planetoid, and we'd never see another one of their students again. And the investigation ... CYU would have our asses."

There was silence for a moment. "There will have to be an accident. That's all I can say." A long-fingered, chocolate-skinned hand gripped the miniature sword hilt until the knuckles whitened. "I have a responsibility to this girl, my friend. I touched her as a child. I planted the command. I pulled the strings to get her admitted. It's because of me that her life is shattering. She could have lived as happily as possible on that repressed 'roid, headblind until the day she died."

The man rose and shrugged. "Gods be with you, then, Holy Damned One. It's a dangerous game you're playing. We'll all disavow you in a minute if you get caught, though. You know we have to." He sounded sad.

"I know." An equal sadness met his tone. "Someday, when there are enough of us, it will be different. But right now, there's work to do. I have to procure a dead body by Friday."

Deseret tried to lose herself in her studies as the transport whished along. *We need transports this quiet on Adam-Ondi-Amen,* she thought to herself. *I couldn't study with their rumbling racket. So much to learn, and I may not be the one to learn it after today.* She wondered, her stomach knotting, what she could possibly say to Elder Nephi that could explain her nightmares. Would begging help, pleading? Not likely. The transport stopped at the dorm row before hers and the last two passengers exited, leaving her alone. It made her feel even more abandoned, somehow. She very nearly got up and left a stop early, but there was no point in delaying the inevitable.

Then, like a sudden glimpse of hell, the transport blew up. Flames cascaded down the aisle like a flood of crackling death. Deseret screamed, turned to run, and the floor fell out from beneath her. There was blackness, and impact, and then nothing for a long time.

A light at the end of the tunnel—the long darkness that stretched on forever. Sensations rocked her as she stumbled along: pain, heat, trembling. *Am I dead? Am I going to hell?* Sometimes the ground beneath her feet was sharp hard rock, sometimes vague sponginess. She kept her eyes fixed on that tiny point of light, the point that never seemed to get any closer.

Then, like magic, there was a presence beside her. Deseret felt rather than saw it, and then she could see her clearly, like a deep pink in the darkness. Neidra stood a little way down the tunnel, looking around with a worried expression on her face. "Deseret?" she called. "I know you're here. It's all right, I'm going to help you find the way out, but you have to help me first. Can you hear me? Call out anything, I'll find you."

I hear you, Deseret wanted to say, wanted to scream, but her throat somehow didn't work. It seemed a desperate effort to get air into her lungs. Finally, as she clutched the painfully rough rock wall for support, she managed to get out a small sound, like the mewl of a lost kitten. She couldn't imagine how Neidra could hear it, but she did. Her eyes focused on the Adamian girl just ahead of her. "Why, there you are! Your light's so dim, I almost missed you completely! Here, take my hand." She held out her slender fingers, and Deseret almost flinched away. *I can't,* she thought wildly. *I'll be ... but if I'm dead, it doesn't matter anymore. Nothing matters. Is Neidra dead too, or—* "Are you an angel?" she choked out.

The small dark girl laughed like bells chiming. "You poor thing. Come on, I'll get you out of here." The extended hand glowed with rose-colored light; Deseret noticed that the warm glow somehow came from within Neidra, lighting her up from the inside. Afraid to trust, but more afraid to be marooned in this dark place, she reached out hesitantly and was seized.

Instantly they were flying, or were they standing still and was that point of light rushing toward them? In moments, it seemed, they were standing on the threshold of a great cavern. Glittering stalactites dripped from the ceiling, and the room was lit by a pulsing glow of magenta, scarlet, wine, violet, all the colors of blood. A crowd of figures danced, whirled, writhed to the pounding beat of strange elusive music that slipped away when you tried to listen to it. Neidra's hand on hers was like an anchor; she clung to it in confusion. There was no question; this was the place of her dreams. Maybe this was hell. Maybe Satan had lured her with evil dreams into committing sins, and then killed her at the moment that she was most impure. Neidra, at her side, towed her as if she were a weightless fluff of thistledown toward the center of the cavern, where a tight ring of people obstructed the view, all mysteriously glowing from within with shifting colored light.

Deseret panicked and tried to pull away, nearly blind with fear. "Stop!" she shrieked. "Get me out of here! I'm a good girl, a daughter of Ad—" Her cry was muffled as Neidra, with an iron grip, pulled her into her arms and held her tightly.

"There, there, it's all right, no one is going to do you any harm here," she murmured as Deseret struggled weakly and then gave in. Her face was buried in the dark cloud of Neidra's hair, and it smelled of spices, pungent curry and sweet coconut, and this was so near to her secret fantasy that her will gave out and she surrendered, limp as a baby, to

Neidra's gentle stroking. Her thin body felt as if it was on fire, a growing warmth spreading outward from her groin. It was a completely unfamiliar sensation. *This must be hell; I can feel myself burning. I'll burn up. I'll be consumed in the flames of perdition and suffer endlessly.* Yet the warm pressure of Neidra's naked body against hers was so pleasant that some part of her could not really believe—naked? Why hadn't she noticed it before now? Neither of them had any clothing on. Bronze skin glided against pale flesh as if greased, like rivers flowing together... *No!*

Deseret had not been naked since the age of twelve. *My temple garment—but no, I'm dead. I couldn't bring it with me. I'm damned, damned to burn forever.* Tears gathered in her eyes and she let out a moan, rubbing herself instinctively against Neidra's thigh, anything to ease the torture between her own. And then Neidra's mouth was on hers, her curry-spiced tongue invading Deseret's mouth, and nothing else mattered. When the kiss finally ended, Neidra wiped the tears from her cheeks and stroked back her matted, mousy hair. "Feel better?" she asked.

Actually, from the waist down, Deseret felt worse. The heat and burning sensation was nearly intolerable, and she felt her organs swelling as if they would rupture. Wetness poured down her thighs, and she was afraid to look, assuming something had burst and it was blood. But her fear was somehow lessened by Neidra's gentleness and presence, and she resigned herself. "If I'm damned," she whispered, "I shall do my best to endure these torments with courage, and perhaps I shall eventually be released." Her heart beat faster. "Just—just don't leave me."

The Bhaktipan girl laughed at her, eyes twinkling in the way that had always secretly charmed her. "Poor little Deseret. Still thinking this is hell! Oh, sweetheart, how wrong you are. This is just part of the Aquila Dream. I'll show you."

She turned and made for the circle of people again, towing a limp Deseret with her. Pushing between them, she brought the Adamian girl forward to see first a fire that leaped bright orange in the center and then— Deseret stiffened, more sure than ever that this must be hell, and she was witnessing the torments of the damned.

Spread-eagled against a dark shape on the far side of the fire was a young boy, his face contorted in an attitude of what must be suffering. As he turned his head, she recognized him briefly from her zero-g gymnastics class. Another young man stood before him, burnished skin gleaming in the flamelight, laughing as a whiplike coil of energy flew from his fingers, caressing the other boy's body. He flinched and writhed, and cried out, thrusting his pelvis forward. As they came closer, Deseret could see his cock, erect and unafraid, obscenely swollen. His tormentor reached out and stroked it, and he cried out again, humping the grip. The sight almost made her turn away, but somehow her gaze was caught and she watched, mesmerized, as they boy was whipped and stroked by turns until he screamed and spouted white fluid in a graceful arc.

Neidra was behind her, full breasts pressed up against her back, hands roving her body, hot breath coming in pants in her ear. Deseret automatically pushed her hands away when they brushed her breasts, her nipples as hard as they might be in cold weather, but there was no cold here, only the burning. Neidra tried again, only to have Deseret cover her tiny naked breasts desperately with her arms. Her trust in Neidra warred with the shame she felt. Then the Bhaktipan girl forced the issue and pried Deseret's hands away, her grip terribly strong in this strange land of death. One arm pinned her about the waist, holding hers down; the other slim brown hand found first one nipple and then the other, rolling and twisting them between the slender fingers. Her groin felt as if

it would explode, and she moaned in terror and ecstasy. Neidra let go of Deseret's arms to press a palm firmly between her legs, and the pressure felt good, a relief to the throbbing swollen sensation. The second her arms were free, though, she folded them instinctively over her breasts again, and her thighs clenched on Neidra's hand, unable to stay open.

The darker girl sighed and turned Deseret around to face her, a look of frustration on her face. "You just can't help yourself, can you?" she said, as though she was not expecting an answer. "Oh, well, we have ways of getting around that too." She took Deseret's hand again and towed her toward the far side of the fire, where the dark shape waited.

Terror built in her throat, paralyzing her, blocking any scream she might have made. The shape loomed, and it was a woman, dark as a storm, cloaked in black—or were those wings?—whites of eyes and teeth the only points of light, and yet her out-thrust hands were limned with gold, gleaming like the first morning sun around the blinds. Something moved in the depths of the frightened girl's mind, and she cried out, once, "I know you!" and spoke a Word, one Word, with sudden utter certainty.

The memory spun within her, fragmented like a broken mirror. A woman, dark as a storm, bending over her child's form, touching her forehead with fingers whose edges glittered golden (or had it all been a trick of the light?) and saying something, laying a traitorous seed deep inside her. The shock held her for one moment, and then those mysterious hands gripped her wrists and she was drawn up, spread out, her body taut and facing the firelight. Her struggles might have well been against a steel wall.

Something fastened on the side of her throat like a lamprey and then she felt all the fear simply drain away, as if it were being sucked out of her, leaving her weak and still

burning. Neidra appeared in front of her and their mouths melded in another long kiss. This time, when her fingers found Deseret's nipples, she was unable to protect herself. Neidra's kisses replaced her hands on Deseret's breasts, moved down her stomach, over her pubic mound. Unseen hands gripped her ankles and dragged them apart as the fluffy dark head buried itself between her labia, licking and sucking. The Adamian girl cried out with the last of her will, and then she was lost in the great flood of sensation that contracted within her again and again. *Perhaps,* came her last conscious thought, *this is the fire that purifies, the flame that will release me.*

She came to slowly, finding herself lying across a narrow bunk, insulating blankets wrapped around her. A warm body pressed against her through the covers, and Neidra's voice was speaking to someone from what seemed a great distance above her.

"—and we ought to make Aquila by eight tomorrow morning, Standard time, assuming Danila's as good a pilot as she says," the Bhaktipan's merry voice came. "I hope she'll be all right. It'll be a great shock to her."

"You may have to use a sedative if hysteria threatens. I won't be there to eat her fear this time." Deseret wondered lazily who that authoritative female voice belonged to. It sounded awfully familiar somehow. She moved in the warm covers and Neidra noticed her.

"Gotta go, Holy Damned One. I'll keep you posted." Then Neidra was stroking her hair back from her face. "How are you feeling? Are you hungry?"

Deseret struggled to sit up. She was naked, as in the dream—had it all been a dream?—but the room was an ordinary ship's bunk, of the kind she had ridden in coming

to CYU. And her body felt more real, yet somehow different. "I'm not dead," she whispered. "Not dead."

"No," said Neidra matter-of-factly. "And yes. The person you were is dead. The Adamian Elder was told of your death. Your family has mourned you. Legally, you no longer exist." *But it's all right, you'll do fine.*

The last words were not spoken aloud, and yet Deseret heard them clearly, Neidra's voice echoing in her mind. Her eyes widened and she clutched at the covers. "What! How—"

The darker girl sighed. *Speech is so useless in conveying concepts like this,* she said silently to Deseret. *Look. Listen.* Her fingers brushed the Adamian girl's forehead and a flood of images poured in—people, many people, gifted in strange ways, all hiding, seeking out their kind one by one all over the settled worlds, being spirited away to have their gifts trained because a developing psi mind might be a danger to those around them, might go mad from their proximity. Her dreams—the group dream, the Aquila Dream created by all the psi minds on CYU, existing and yet nowhere, that had sucked her in. Her suit, the temple garment that had prevented her from feeling bodily desire—this was revealed to her with a fillip of disgust from Neidra—sliced off by someone's (whose? *You'll find out someday,* Neidra said) capable hands, her hormonal balance normalized, and then the two days of laying semiconscious in Neidra's arms. A lover's arms, being stroked and touched and brought to pleasure again and again, physically and mentally, as the ship sped on its way to—where?

"Aquila," her lover whispered to her. "You'll find out when we get there. I can't explain it to you just yet; your mind can't take too much interfacing until you're stronger."

Deseret sank in a fog of confusion. "Then I can't ever go home again? she said in a small voice.

"You can go back as soon as it's safe, I promise. You just need some training," Neidra assured her. *And then you'll be a perfect little walking time bomb,* said a strange echo in the air, but Neidra kept on talking and Deseret, shaking her head to clear it, dismissed it as a product of her confusion. "I'll be with you for the first two weeks, the prof—uh, friends in the system will cover for me at CYU, and by then you ought to be settled in." She snuggled close to the thin Adamian. "Trust me? Please?"

Deseret looked into her brown eyes, sensing that Neidra was withholding mental contact in order not to pressure her, and made her choice. *Even if I do eventually burn in hell,* she thought to herself, *if it looks anything like the Aquila Dream I'll manage.* "Can—can we go back there? To the Dream?"

Neidra shook her head. "We're out of range here, in space. But we can rejoin it again, on Aquila. In the meantime"—and her hands were slipping seductively under the blankets to touch Deseret's newly exposed skin— "we'll just have to amuse ourselves in this dimension. We have been, all along, you know; you just don't remember it."

"We have?" Neidra was closed to her and she had no way of telling the truth of this statement.

"We have. You're so sweet and responsive ... especially when you're tied up." She lowered her mouth onto Deseret's, and the new psi felt her energy hum in time to the ship's drive as it hurled her off to a new future, painted in all the colors of blood and desire.

Kitty Tsui

Why the Sea Is Salty

A long time ago when the ocean water tasted like rain, there lived in the mountains an old woman. She had long white hair streaked with gray that fell past her knees. Her skin shone with the oil she extracted from the needles of the rosemary bush that grew outside her cave.

One day a crane was flying in the heavens scanning the earth for food when it saw a silver mass shimmering in the water below. Thinking it was a school of fish, the crane began its descent. However, as it got closer the bird saw, not multitudes of fish, but a creature with a silver mane. Forgetting its hunger, the crane settled on an overhanging branch to watch this curious beast.

The woman laughed her welcome. She shook her head wildly, her hair flying in dancing sheets about her body. In her frenzy she began to sweat, releasing the rosemary oil to the air. This pungent smell drew the crane closer and closer to the women until it was standing in the water between her legs. With a motion of her head, the woman flung her hair over her body like a covering and pulled the bird gently against her.

The crane fell into a deep sleep cradled in her arms.

Some months later, on a night of the full moon, the stillness in the mountains was shattered by screams. Eagle, owl, and raccoon stopped. Eagle tore open the night with her keen eyes. She saw the old woman squatting at the mouth of the cave.

In the early hours of the day, a child was born.

Years passed. The child grew to maturity, but she was unlike any child you and I have seen. From her kin, the crane, she had inherited a long neck and a covering of white feathers that ran down her neck and chest and ended just below her breasts. She had the blue-black hair of her mother's youth and strong, sturdy limbs.

Her mother taught her to live the way of the creatures. She ran the hills sure of foot and swift as the deer. She swam and played in the river surrounded by many minnows. She understood the language of the sparrow hawk and the cicada. She greeted the rising sun with a song, and the setting sun, a dance.

For nourishment mother and daughter drank from the clear waters of the river; this was their food and water. They needed nothing else.

Crane Girl had grown into a beautiful young woman. Her body was smooth and brown, the muscles rippling under the dark skin, the white feathers a striking contrast to the rest of her.

Now the old woman had lived a long time. The years had etched deep crevices on her face and hung heavy on her limbs. She could no longer match the energy of her daughter. She was very tired and she wanted to rest.

One night young Crane Woman was awakened by loud thunder. Her mind was groggy. She blinked her eyes, coming out of a dream. She lay suspended in her own warmth on the bed of pine needles. Suddenly she realized that her mother was not sleeping next to her. She jumped out of bed

and ran to the mouth of the cave. Outside, rain fell in sheets. A sudden gust of wind soaked her. She was about to draw back into the warmth of the inner cave when she noticed a pile of silver hair at her feet. Stunned, she bent over and took a handful. She burst into a loud cry. Her mother's beautiful mane was laid out on the floor of the cave.

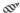

Meanwhile, high in the heavens of the Realm of Clouds dwelt the clan of Poa Poa Lung. They were makers of rain and riders of the rainbow. They lived in the clouds and were guardians of the sacred lakes, the pure water that fell as rain onto the earth.

The dragons drank the water and roamed the heavens. The gods called them riders of the rainbow because of their ability to change the color of their body to the surrounding environments. That is why we cannot see a dragon flying in the sky. It was also said that when a dragon visited the earth she rode on the back of a rainbow.

Poa Poa Lung ruled the clan with a circle of elders. Some time ago her mate, Lung Goong, had sighted one of the first human women, fallen in love with her, and taken her as his lover. Of course all the dragons had disapproved of this action. But by the time it was decided to banish them, the woman was heavy with child and could not travel. It was a long, painful labor. The woman was torn apart when her child was born. Lung Goong took her remains back to earth and was never seen again.

The offspring of this union remained, at the insistence of Poa Poa Lung, who was fascinated with the body of this creature.

Most people think of dragons as huge monsters, but they are, in fact, small creatures only a head or two taller than the average human. They have a long, lizardlike body covered

with scales and a short tail. Their heads are big, eyes bulging from the bridge of the nose; their jaws are prominent. Despite such a formidable appearance, they are very gentle creatures.

The child of the earth woman was as tall as a dragon, but she had the body and hair of her mother. The only resemblance she bore to a dragon was in her hands and feet. In place of fingers and toes she had long rootlike projections.

They called the child Siew Lung and doted on her as if she were a dragon offspring. They adored her smooth body and envied her hair, small face, and delicate neck. But the lines of her jaw, her shoulders and arms were sharp, strong, and the temperament of Lung Goong pulsed in her blood.

Each family looked after a lake. Since childhood Siew Lung had lived with different dragons, but now she drifted about from place to place doing whatever she fancied. Unfortunately, she had gotten so vain that she spent most of her days admiring her refection in the water.

Now, the Realm of the Clouds is vastly larger than any land mass you or I can imagine. It took much work to keep a check on the flow of water and to regulate the amount of rain that fell, so flooding would not occur.

All loved Siew Lung, but there were those who were jealous of her beauty. It began as idle chat, but the evil talk grew and grew until it reached the ears of Poa Poa Lung.

"Little Dragon is lazy and sets a bad example to all."

"She admires herself in the holy waters all day."

"She is plagued with an unnatural body. What if other dragons mated with humans?"

"What if her kind took over the Realm of the Clouds?"

Poa Poa Lung had never been close to Siew Lung. But when she was called upon by the circle of elders to tell the young one of her fate, the old one shed tears.

"Siew Lung, you are banished from the Realm of Clouds until the day you rid yourself of vanity and laziness."

Meanwhile, below the heavens, many moons had passed since the old woman's disappearance. Crane Woman talked with swallows and goats. But none had news of her mother. The storm that had awakened her on that fateful night raged on.

Crane Woman lay in bed and cried. She missed her mother. She did not sleep and did not move from where she lay. Finally, she lost consciousness.

When Crane Woman came to, she was holding herself in her arms.

The storm had subsided. Flocks of birds sang and the mountainside awoke and rang with activity. Crane Woman stepped gingerly out of the cave into the bright daylight. She dropped to her knees and put her lips to the soft, soggy earth. Then she went to the river and drank from the swollen stream. She climbed to the top of the mountain. The sight she saw made her cry out. A rainbow of colors stretched from horizon to horizon.

Everything around her oozed wetness. Her heart opened like a sea anemone. She breathed the sweet scent of the forest and for the first time in many moons, she was glad to be alive. Suddenly, above the excited chirping of the birds and the dripping of the forest, she heard unfamiliar noises. It sounded like a creature in distress, wheezing and out of breath. Crane Woman did not waste any time but sprang off to investigate.

The noises led her past a clump of ancient redwoods. There, in the middle of a clearing, sat a strange-looking beast, sobbing and rubbing its eyes. Crane Woman did not know if she was awake or in a dream, because the beast was rather difficult to see. In fact, she looked right through it and saw the earth on which it sat. Swallowing her surprise, she asked, "Pray tell, gentle creature, what is the matter?"

Siew Lung jumped to her feet and shouted, "Who's there?"

Crane Woman walked out of the trees and approached the beast. "I am daughter of crane and daughter of woman."

Unfortunately for the dragon, along with being banished, she could neither see herself nor anything that was close to her.

"I am lost and far from home. I am tired and hungry and I cannot see where you are."

"Are you without sight?" Crane Woman asked.

"Only if you are close to me. Step back to where those trees are and I will be able to see you."

Crane Woman did as she was bidden.

"Oh my," exclaimed the dragon, "we look alike."

Though it was harder for Crane Woman, she could see what the other meant. They had the same face, the same limbs, the same body—save for Crane Woman's feathers—and both had long hair.

"I am called Siew Lung, Little Dragon. My father was Lung Goong and my mother was a woman."

Crane Woman could hardly contain her astonishment. "Then you are my kin! Welcome to the mountain. Let me take you to my home and you can rest and eat." She took Siew Lung by the arm and guided her to the cave.

"What do you eat in your land? Berries, leaves, or grass? Or," she added, without hiding the disgust in her voice, "do you eat the bodies of dead animals?"

"Heavens no," exclaimed Siew Lung. "I eat and drink only the pure water that flows in the clouds."

Crane Woman was much relieved. She went to the river and filled a hollow gourd with water.

They spent the next weeks telling each other about their lives. Crane Woman took Siew Lung on long climbs up the mountain and introduced her to animals, birds, and fish. At

first they were suspicious of a creature they could barely see. But they all loved Crane Woman and began to trust this stranger who was her friend.

In addition to the inability to see things close to her, the dragon had been stripped of a number of other things. She could no longer fly and had lost the power of total invisibility. Sometimes one could see just the outline of her body, and other times one could see it more solidly.

☙

"Little Dragon, let us go down to the lake," Crane Woman said one hot afternoon.

The two ran through a thickly wooded area and across an expanse of grass to a body of water ringed by huge boulders. Crane Woman climbed up on a rock and dove in while Siew Lung stood watching.

"Come on!" Crane Woman shouted as she swam to the other side of the lake.

Little Dragon shook her head.

"Why not?"

"I cannot. The waters are sacred to us."

"That was in the heavens. This is earth. The waters may be sacred, but we drink it to survive and we frolic in it for play. Come on," she laughed, getting out of the lake and climbing on to a boulder.

Siew Lung looked at her friend's body glistening in the sun as if seeing it for the first time. She stared at the fine line of her neck, the rippling muscles, her dark hair a sharp contrast to the white feathers.

Something stirred inside her, an ache, a strange sensation in her heart. At the same time a warmth spread in the place between her legs, as if that part of her alone had been left out in the hot sun. She gasped out loud. Was this the forbidden power the dragons had warned her against?

At that moment she sensed her friend by her side. Crane Woman took her hand.

"What are you afraid of?" she asked gently.

Little Dragon felt her friend's breath close to her face. A roaring like thunder filled her ears. Heat enveloped her being. A cool hand touched her shoulder.

"What is wrong?" Crane Woman probed again. "Oh, you are shaking."

Little Crane drew her close and put her arms around her friend. Then, as quick as a flash of lightening, she leaned in and kissed her.

When Crane Woman's lips touched Siew Lung, her insides tingled. She opened her mouth and felt a long, soft tongue sliding in. She sucked then, and a wave of exquisite pleasure flooded her senses. She heard herself moaning even as she felt herself falling from a great height.

When Siew Lung came to, Crane Woman was looking at her with concern.

"What happened?"

"I do not know. Only that I was falling. And dragons never fall."

She shook her head, puzzled, as tears fell down her face.

Crane Woman held her friend in her arms and rocked her.

"You're safe here, Little Dragon, you're safe with me."

The two became fast friends though they never talked again of the kiss. Crane Woman laughed and danced as she had never done before. But she could not forget her mother and resolved to find her.

One night she dreamt she was walking across an expanse of sand. The sun beat down on her. Her feet were swollen and sore, but she kept on. In the distance she saw a geyser bursting from the sand. When she got closer, the water had

changed to a burning bush. In the yellow flames she saw her mother's face melting.

Crane Woman woke up screaming, tears running down her face. Siew Lung held her and rocked her as she told the nightmare.

"Something has happened to my mother," she sobbed. "I must find her, I must help her." She struggled to get up but Dragon Woman would not let her.

"Tomorrow, tomorrow before the sun is up we will go. Rest now, sleep now, Little Crane."

Early the next day the two friends prepared to leave. Siew Lung filled gourds with water. Crane Woman took her mother's hair and braided it tight into two braids, interweaving hair with dried sprigs of rosemary. When this was done, she wrapped the braids around her belly. They began their journey.

The going was slow. Crane Woman guided her friend with her voice, and at other times they walked together, hand in hand. "Will I ever regain my sight," Siew Lung wondered. "I will never spend time looking at myself. Never, never, I swear." But the only answer was the high-pitched scream of a hawk and the wind in the trees.

"Woman friend, do you think I will ever see again?"

"Perhaps on our way we will find some cure, or the right prayer that will help it back."

They followed the river downstream until they had left the mountain far behind. All of a sudden, the river dipped and ran bubbling into a huge hole ringed with rocks. The friends drank their fill and took what they could with them.

Crane Woman led Siew Lung across another mountain. Little Dragon's rootlike feet dragged heavily on the ground, leaving snaking trenches in their wake.

Crane Woman stopped, her words coming in spurts.

"Do we not have a drop? I'm very thirsty and about to fall."

Siew Lung wiped the sweat from Crane Woman's face and whispered, "We finished the last days ago. Let us rest in the shade until the sun sleeps."

The two friends, weak and spent, nested in each other's arms.

By the light of the moon the two forged a path through thick forest. In the daytime they rested in places of shadow and tried to regain their strength. One day Siew Lung had blackouts.

"We must have water, we must have water," chanted the delirious little crane, leading them round and round in circles.

"I hear a river," shouted Siew Lung and they quickened their steps. But hours later they had not found it. Perhaps it had been the wind spirits laughing in the treetops.

"We must pray for guidance," whispered the little crane.

"I don't know how to. Besides, what good is that going to do?" grumbled Siew Lung.

Little Crane dropped to her knees. "First we must humble ourselves before the earth. When our hearts are open we can ask the spirits for help."

Then the two friends slept. They were awakened by loud noises. It sounded as if a large creature was moving rocks and trees and hurling them from its path. A big black bear was smashing through the undergrowth. Crane Woman pulled Siew Lung up hurriedly, for they were right in its path. The bear did not see them until it had stepped on the Little Dragon's big toes. It looked from one to the other with startled eyes.

"What a strange pair! What are you doing here?" asked the bear in a gruff voice.

"Looking for my mother," whispered the weak crane, "and her vision," nodding at her friend.

"Your mother and your vision," laughed the bear. "Why I've never heard of anything so funny in all my years!"

Great gusts of laughter shook the enormous belly of the bear.

"Yes, and we're lost and hungry..."

"Hungry!" bellowed the bear. "Hungry! Why, you're in the great forest surrounded by food." It hesitated. "What do you strange beasts eat? Not bear meat, I hope."

"Oh no, water."

"Water! Well, that's easy. Follow me, I'm on my way to the river for a midnight snack."

Much later the bear was asleep with a full belly, Crane Woman was floating in the water, and Siew Lung was sitting on a rock.

"How do you know we're going the right way?" Siew Lung asked. "We don't even know where we're going."

"I have to trust my heart," replied Crane Woman, blowing water out of her mouth.

"Chee!" shouted Siew Lung with disbelief, "why don't we ask the bear? Even in the clouds we know the bear is a wise creature. She'll help us. Bear, Bear, are you sleeping?"

"Ssssh. Don't wake her. She *is* sleeping."

"But I want my sight back and I want to fly again. All this walking wears me out," whined Siew Lung. And with that she began to cry loudly, sneaking peeps at the slumbering bear.

"What's all this racket about?" growled the bear.

"I can't see," sobbed Siew Lung, "and my feet hurt. Can you help us?"

"You will learn, young one, that when you are punished, the way back is not easy. And," turning to Crane Woman, "as for your mother, I cannot say..."

"Then you know about her!"

"All I can say is, find the Golden Rabbit and the truth will be known."

"How? Where?"

"I will say no more. I am grouchy and I hate being awakened when I am not ready to be. Now off with the both of you."

"But, Bear, where?"

"Purity flourishes in open fields. Go. Grandmother Moon watches over you."

With that, the bear turned her back on them and went to sleep.

The friends continued, passing mountain and meadow. One day they stood at the edge of a bamboo grove, looking over a sea of sand that stretched to the horizon.

"Little Crane, are we going to cross the sand?" asked Siew Lung, staring wide-eyed at the desert.

Crane Woman nodded.

"Yes, after a rest we will cross and be close to the end."

"We will? How do you know that?"

"I feel it."

To tell the truth, Crane Woman was feeling lost and discouraged. She did not know how much farther they would have to go but she did not want Siew Lung to know her despair.

When the moon rose they started across the desert. Weeks passed. The sandscape had not changed. Their water supply was almost gone. Little Crane was weak from lack of water.

"Siew Lung, take my mother's hair from around my belly and go on. Leave me. I cannot go on any farther."

Little Dragon knelt beside her and started to cry. "I cannot leave you. You are my friend, the first I have loved besides myself." She put her face next to the little crane's and let her tears fall. Their tears spilled onto each other's dry, cracked lips. Despite her friend's protests, Dragon Woman carried her on her back and they continued on.

By the light of the moon they saw a huge shape towering in the distance. Siew Lung said, "It's a tree, a huge palm."

Indeed, it rose fifty feet into the night sky, its fronds an immense umbrella ringing the thick trunk. It grew, a luscious living jewel out of a barren land. They hastened toward it to sleep in its shade.

When the sun was high and the palm cast no shadow, the two friends were awakened by the fierce heat. They moved closer to the trunk, hoping for some relief. There was none. Suddenly, they were startled by a voice.

"Kind ones, spare me water. I have had none for many years."

"Who is it? Where are you?"

"I am palm. My fronds grow yellow at the tips. I need water."

"No," shouted Siew Lung, "we have only the last drops. Palm, you have lived years without water. We will die. We cannot give you any."

"Siew Lung, maybe we can spare some. How can we deny this palm? We have been resting in its shade. Without it we may have died sooner."

"No," repeated Dragon Woman.

"Please, I beg of you, let me have water. Though you do not see, I am dying a slow death. Please, I beg you, spare me water."

"No, no water,"

Crane Woman looked at her friend with sadness in her eyes.

"I will give the palm my share of the water."

"No," screamed Siew Lung. But it was too late. Crane Woman had emptied the contents of her gourd into the sand.

Siew Lung sighed. "Then I will have to share mine with you."

"I do not want it. If you are true about sharing, give it to the palm."

"But ... but it is the last. There is no more."

"If you are true, give my share to the palm."

Siew Lung hesitated. Then in a swift motion, she, too, emptied her gourd at the foot of the palm.

At that instant they were thrown off balance by a strong gust of water that shot into the air. The palm had turned into a geyser. They were underneath a fountain of water.

They stayed under the geyser for many days. Now that she had been initiated, Siew Lung was content to play in the water, but Crane Woman was anxious to move on. They had been following the stars in a northwesterly path. Crane Woman was suddenly struck by a feeling they were not going in the right direction. Try as she might, she could not shake the feeling.

"What is the way," she asked herself over and over. She told Dragon Woman of her uncertainty, but Siew Lung had no ideas either.

One afternoon Dragon Woman pointed out a cloud to the little crane. "Up there. Does that not look like a face?"

Crane Woman squinted. A cry burst from her lips.

"That is my mother!"

"Your mother?"

Sure enough, high in the sky was the old woman's head; the eyes were closed and the head was bald, like that of a newborn child.

Little Crane strained her head upward. The face stayed with them for only a few moments. The wind made the face wispier and wispier until it dissolved. Tears were running down Crane Woman's face.

"Mama ... mama..." She searched the sky through her tears, but the face was nowhere to be seen. Then, in the west she saw colors—faint shades of lavender, yellow, orange.

"Look, do you see what I see?"

"Yes, a patch of colors."

The two friends looked at each other. What did it mean? Why the face in the clouds? The patch of colors?

"Maybe your mother is trying to guide you," offered Siew Lung, "telling you to follow the direction of the colors."

"Why does she not come to me? Why are her eyes shut? Mama, I miss you so. Why did you leave me, why?"

"Your mother is with you. She's above us, in the sky."

"She's gone," sobbed Crane Woman, "gone."

Siew Lung pulled the little crane to her and hugged her. "Your mother is not gone from you. She is watching over you like a star and showing you the way."

"But I miss her."

Siew Lung held her and stroked her feathers.

"Let us rest now. The way ahead has been shown. Sleep, dear one."

The desert sloped gently upward. They battled the sand that sucked hungrily at their feet. At the end of the third night, Siew Lung said she could smell a large body of water not far off. Soon they both heard the sound of a mighty river. The air around them was electric with motion. All of a sudden the ground in front of them dropped. They were face-to-face with the ocean.

"The sea," breathed Siew Lung. "I have heard talk but never thought it was so big!"

The two were standing near the edge of a cliff. By the first light of day they could see white crests swelling and breaking. Some ways out from shore a huge white rock rose out of the sea. Through the ages the waves had sculpted the stone into the shape of a huge fist with two fingers in the sky. As the sun climbed from the sand behind them, its yellow rays painted the rock with a golden glow.

A truth dawned on the little crane.

"Siew Lung, we have found the Golden Rabbit!"

They were so excited they could hardly stand still. Unfastening the gourds from around them, they took off in opposite directions to look for a way down. The cliff dropped straight to the water. Its face was smooth and afforded not even the slightest toehold.

"How are we to get across?"

But the waves gave them no answer. They looked helplessly out to sea.

In the distance Siew Lung saw a flock of birds headed toward the cliff. As the birds got closer, they could see they were huge; the wingspan was triple the size of other birds.

"Albatross," said Crane Woman. "I have an idea. We will ask the birds to take us across. Albatross, will you help us?"

The birds hovered above them.

"What is it you wish?" one of them sang out.

"Please, could you take us to the white rock?"

"We are going to nest, we are going to nest," chorused the birds.

"Please, we must get across," shouted Siew Lung.

"Must!" mimicked one in an arrogant tone, "must, they say!"

"What will you give us in return?" screeched another.

"We have nothing but the gourds," shouted Crane Woman.

"What's in them? What's in them?"

"Water," replied Siew Lung.

"Water! Water! We live by water. We don't need water from you!"

Crane Woman unwrapped one of the braids and held it up.

"I will give you my mother's hair. You can line your nests and your young will be warm."

"Ha ha ha, yes, yes...," they screamed.

One of the birds swooped down and snatched up the braid in her bill.

"I will take you across. Grab my feet, one in each hand."

"What about my friend?"

"One braid for each of you," laughed the birds in unison.

"But, please, the other is all I have to remember my mother."

"One braid each, one braid each," sang the birds.

Siew Lung sank to the ground. "Little Crane, go without me. Find your mother. Don't worry about me."

"You are my sister. We have come all this way together. You did not leave me. I will not leave you."

And with that she took the remaining braid and offered it to the birds.

The shore was left far behind. The smallest of the three albatross led the way; the other two carried Crane Woman and Siew Lung. Below them, the rock glistened like fine jade.

"We're here, we're here at last!" And the two jumped up and down and hugged each other till tears welled up in their eyes.

They walked around. They looked up at the giant fingers. They looked down at the waves. They looked at each other. Nothing grew on the rock; it was as smooth as an egg. They sat down. The rock was warm, heated by the sun.

"So we have found the Golden Rabbit. But it is not even alive! It is a rock! How is it going to help us?" shouted Siew Lung.

"I don't know ... I don't know..."

The two friends sank into exhaustion and slept.

Crane Woman entered the land of dreams. She was young Crane Girl playing in the river. She saw her mother coming toward her, arm outstretched. There were three small pebbles in her palm. She gave them to her daughter. The old

woman turned and looked at herself in the water. Without a word she walked deeper and deeper until the river swallowed her. Crane Girl felt no alarm. She held the smooth stones in her hand and put the coolness to her lips.

When she awoke the moon was big behind wispy clouds. She thought about her dream and felt strangely exhilarated. She looked at her sleeping friend and felt a sudden tenderness toward her. A desire to touch Siew Lung's body overwhelmed her senses. She leaned and shyly planted a kiss on her cheek. Little Dragon stirred.

"Umm ... what is it?"

"I ... I think I love you."

They fell into each other's arms. This time Siew Lung did not hesitate. Even if this was the forbidden power, it felt too good to be bad. Their kisses were at first awkward and shy. But it was as if their insides were on fire and the flames soon spread over their whole bodies. Their hands lingered over each other's back, thighs, faces. They kissed long and deep. Siew Lung nuzzled her face in Crane Woman's feathers. She took her nipple into her mouth and gently sucked on it. Crane Woman felt delirious. Soft moans escaped from her lips. Siew Lung's mouth moved down to Crane Woman's belly. She stroked the place of soft feathers between Crane Woman's legs, parted them, and kissed her. Crane Woman thought she would faint. Every pore in her body cried out with joy.

Siew Lung felt light as a butterfly. She was soaring in the clouds, her body glistening, her hair flying about her. She heard her friend moaning her name and her heart danced madly as she answered back.

The two fell asleep locked in an embrace.

Siew Lung woke first. The sun was warm on her body. She felt Crane Woman against her and she smiled. She wanted to stretch, but she did not want to disturb her friend.

As she moved her fingers she felt something roll in the palm of her hand. She was holding three pebbles.

Crane Woman stirred beside her. Siew Lung turned and saw her friend's beautiful face soft with sleep. She gasped. She blinked her eyes. The little dragon saw Crane Woman's face close to her for the first time. She could see!

She took in everything around her: the yellow light on the white rock, Crane Woman's hand on her stomach, her own rootlike toes, solid as the rock. She wanted to shout, to sing. She wanted to share her joy with her friend. But she did not wake her. Instead she looked at the stones in her hand. How did they get there? She did not recall picking them up. Puzzled, Siew Lung looked at the ground around her. It was smooth; there were no loose stones.

Crane Woman opened her eyes and looked at her friend with a shy smile.

"The corners of your mouth are so beautiful when you smile."

The little crane gasped. "Siew Lung, can you see?"

"Yes," she laughed. "Your eyes are a wonderful gray like the fog that covered us last night. Your skin is brown like the soil around your cave."

The two friends could not restrain themselves. They rolled around hugging each other and whooping with joy. Then Siew Lung remembered the pebbles in her hand.

"Dear friend, I have something for you. Close your eyes and open your hand."

As soon as she was given the three stones, Crane Woman shouted, "It is three pebbles. They are white!" She opened her eyes and, indeed, they were.

Crane Woman told her friend of her dream. They began to dance around.

"This white rock is a magical place," they sang.

"My mother came to me with three stones..."

"And I woke up with them in my hand!"

A strong gust of wind hit them. Siew Lung stretched out her arms and leapt into the air. The wind carried her higher and higher on invisible wings.

"Little Crane, I am flying, I am flying!"

Dragon Woman soared above the white rock, shouting with glee. Then she dipped her body and flew down to the crashing waves. The spray hit her face and wet her body.

Crane Woman dropped to her knees and wept. She gave thanks for her dream and the gift of the white stones; she gave thanks for the return of Little Dragon's powers. For the first time she accepted that her mother was gone. But she had the white stones and she had a fine friend. And she had herself.

Crane Woman climbed onto Siew Lung's back. They flew over the ocean, leaving the white rock far behind. After traveling for some time, Siew Lung sighted a beach and they stopped to rest. They lay on the warm sand. Crane Woman had not spoken since they had left the rock.

"What is the matter?" asked her friend gently. "Are you sad we did not find your mother?"

Crane Woman shook her head. She got up and walked into the waves. She bent her long neck and looked at her reflection in the water. She saw something she had never seen before and gave a start. From the front of her head grew a thick streak of gray. She ran to her friend.

"Siew Lung, look!" She pointed at her hair.

"Oh, Little Crane, it is just like your mother's."

"Yes, yes..." And she broke down in tears and laughter. "My mother is not gone. I am my mother! I am my mother!"

The two friends came together. They touched and kissed each other's bodies. Siew Lung nuzzled the salty tears from her lover's face. They breathed the fragrance of their armpits and explored the wetness between their legs.

116

In their ecstasy they rolled to the edge of the water. Siew Lung rolled on top of her friend and pushed her long fingers inside her. Crane Woman gasped.

"Do I hurt you?"

"No, no, it feels good. Your fingers in me are roots. The fire in my heart for you is ancient."

"I love you," cried out Little Dragon, "I have always loved you."

Siew Lung groaned as she pushed deeper, sliding in easily, feeling a delicious heat engulf her hand. An urgency gripped her and she moved in the velvet wetness, as if she were a separate entity, powered by its own desire. Crane Woman felt each stroke as though it penetrated to her heart.

Every thrust induced an exquisite pain, but she found herself arching her body up to receive it even as she cried out. Suddenly, a wave of pleasure crested inside her and a mighty roar burst from her lips. They held each other then, and kissed slowly, savoring each other's lips, tongues. Crane Woman sucked the dragon's long fingers, marveling at the salty taste in her mouth. She felt a mad urge to bite down hard, so she sank her teeth into the other woman's arm. A strange, sweet essence filled her mouth, a fragrance that tasted tangy and metallic. She knelt above her friend and parted her legs, a groan issuing from her lips as she sank down.

They made love by the edge of the water for a long time. Their orgasms exploded with the fury of tidal waves; their juices overflowed, mingling with the water.

That, my friends, is why the sea is salty.

Katya Andreevna

Goddess Love

"I don't really care what you think," Sheila said and stomped out the door of my apartment.

I got up from the couch to follow her, but stopped at the threshold. My nose was running and my eyelids throbbed. I held on to the doorknob and let the salt drip down my face. Our monthly fight was over. As usual, Sheila was off to seek solace in the arms of another woman.

I was left with the shards of the mug Sheila had thrown earlier and a pounding headache. I splashed my face with cold water and dug the dustpan out of the hall closet. It was only one in the afternoon and yet I was powerfully drawn to my bed. I could not let myself sleep.

Yoga class, I thought and checked my wallet. Slumped in a chair, I counted out seven one-dollar bills. I was three dollars short. I sat staring. I couldn't stay in the house, not with the echoes of our fight bouncing around my head. I went to find my emergency money. This, I decided, qualified as an emergency. I opened the old candy tin with the Canadian Mounty on it, expecting to find the twenty I kept there. A few stray shirt buttons, some political campaign pins, no money.

Damn, Sheila. She's probably treating some girl to drinks this very moment. Then late tonight or tomorrow she'll come

crawling back and expect me to nurse her "bad stomach." She never used the word "hangover." But then again, neither did I.

My nose started to drip again and my eyes clouded. I held the gold locket around my neck, trying to warm the cold metal. In my mind's eye, I saw them, standing at a bar, Sheila telling a charming story and she, the other woman, bending her head and laughing. Then they ordered fresh drinks.

I thought to call my friend Marcia, but I knew I couldn't. She wouldn't understand. She didn't know how much Sheila loved me.

"Did she hurt you?" she'd asked me the one time I had called her after one of our fights.

"Well, I'm upset," I had responded.

"I mean did she hit you? That's what I'm asking," Marcia had said.

&

I grabbed my coat and plunged out the door. The cool air soothed my burning cheeks. I cut through the icy park and kept going. The faster I walked, the faster I needed to walk, or so it felt. As if I could outpace my thoughts, leave them behind me. The cool metal of the locket danced between my breasts. I made the mistake of turning up Second Avenue and hit the slow-moving pedestrian traffic of the street junk mall. This was where Sheila had bought me the locket. Well, not exactly. On the summer day I had spotted it, a shining heart, sandwiched between some old CDs and a useless electric coffee pot, I had asked her for it.

"What do you want a piece of junk like that for," she had said and laughed. "We all know that emotions come from the brain, not the heart."

I went back, though, and bargained for it. Later that week, after I had cut Sheila's hair, I stashed one of her dark curls in the hollow of my new ornament.

The snowy sidewalk was littered with rows of crumpled shoes, wrinkled blouses, stained dresses. Passersby gawked at the shoddy merchandise as if they were viewing famed museum relics. I twisted past several groups of them only to be stopped by a mound of old electric gadgets. I hopped sideways to get around the bulky objects, but my foot caught and I fell, catching myself on my hands and skinning my palms.

"Oh, lady, let me help you, lady," the man who minded the pile of junk that had felled me crooned. He stood over me and made no move to assist me. I stayed where I was for a few seconds, face to the pavement, collecting myself, squeezing any sloppy tears back into their ducts.

I raised my head slowly. Where I expected to see a man in a hooded sweatshirt and dirty jeans, the Goddess Durga reared up before me. Panic spread through my chest. I crouched on the ground. *Did I hit my head?* I wondered and gingerly patted my scalp. I snuck another look up at her. Her lovely arms seemed to dance about her head, all five pairs of them. Her cool eyes glittered down at me. Her form was brilliantly carved in fluid lines. I looked around quickly to see if any of the shoppers had noticed my silly fright.

You're even scared of a statue—in my head I heard Sheila's voice—*so why would your fear of me mean anything?*

I stood up slowly. The man whose pile of junk I had landed near hovered around me. I couldn't take my eyes from the image of Durga. Finally, I croaked, "How much for the Goddess?"

"For you, lady, seven dollar. Only seven dollar."

I was convinced. Somehow he knew that seven dollars was the only money I had. Surely, then, this statue was to be mine. I handed him my wadded bills and lifted the Goddess from her seat of honor among the electronics.

Although she stood only two feet high, she was heavy. Rushing home the way I had come, I worried that I would run into Sheila, that she would mock me for buying such a piece of trash.

She'll be jealous, I thought. Notions like that made me worry that I was losing my mind.

I struggled up the stairs with my Durga. She seemed to grow heavier with each step. Oddly enough, her weight kept shifting. She didn't feel like an inanimate object. She felt more like a cat in a bag. A very heavy cat.

I fussed around the apartment, finding the right place for my new treasure. When she was finally settled against the east wall of my bedroom, I collapsed in a heap on the floor and looked at her. And then I started to cry. The Mack truck of my troubles, temporarily lost on the road, had found me, knocked me down, and now it waited, idling, wheels on my chest. My sobs forced words out of my chest, things I didn't know I knew, thoughts I didn't know I had.

She will kill me. Steals from me. Loves me. Wants me unhappy. Needs me. Have no friends. Won't let me talk. Suicide. Need to leave. Not safe. She has keys. She made me. I didn't want to. It hurt.

Hiccups racked through me, tearing at my lungs. As I held my cold, gold heart in my hands, I became aware of a rustling noise. My first instinct was to hide. *Sheila must be in the house,* I thought.

A sinuous arm draped around my shoulders, another supported the small of my back. My breathing became more regular as Durga pulled me to her. She smiled at me, and I was not afraid despite the strangeness of this occurrence. I circled an arm around her waist. Animated, she was just slightly taller than me.

"You grew," I said and then felt like an idiot.

"I am always the right size for the task at hand," the Goddess responded. She cradled me in her arms, stroking my back. She rocked me as the last tears oozed down my cheeks. My tears spent, she massaged my neck and my feet at the same time. With each stroke of her many hands, I felt the fear and embarrassment that had gripped my body melting. And as they left, strength and determination took their place.

Gently, the Goddess removed my clothes. She lay me down on the floor and caressed my naked torso. I was surprised by the warmth that began to spread from my loins into my belly.

Should I be turned on by this? I thought.

"Don't worry," the Goddess said. "Enjoy."

She lowered her body over mine, pressing her full breasts against my own. She pinned my arms down with one set of hands, stroked my flanks with another. She nuzzled my neck and, when she began to plant little kisses along my collar bone, I giggled. I couldn't remember feeling so relaxed with another person. I knew I would not have to defend myself against Durga. She would stop when I wanted to, if I wanted to.

Making love with Sheila I was always on guard. On guard for the moment her passion would turn to force. Vigilant against my own reactions lest they provoke the porcupine of her anger and thus leave me full of quills.

Durga rolled off of me. She untied her feather-covered blouse. Her naked, round breasts left me breathless. I cupped one in both hands and brought my face to it worshipfully. She pulled on the chain of my locket with her teeth.

"What are you doing?" I asked.

"Warming your heart," she said. She sucked the locket into her mouth.

And I did feel warmer, but perhaps it was all the pairs of hands that teased my flesh. A pair of hands stroked my knees and inner thighs. While my buttocks were squeezed, fingers combed lovingly through my bush. My breasts sung under Durga's capable fingers. There was too much sensation for me to take it all in and yet my whole body cried out for more.

Durga smiled at me and began to part my slick labia. She tugged on my inner lips and slid a finger around the opening of my honeyed hole.

"Oh, yes, Goddess," I murmured. I shuddered with pleasure as her fingers reached inside me. She moved slowly at first, but then her speed and force increased. Eyes closed, I panted beneath her. With each stroke of her fingers, I felt myself grow. Her energy poured into me. Awash in pleasure, I couldn't tell where my body ended or began. I raised my head from the floor.

Durga rubbed my earlobes and temples with one pair of hands. Another set played a feather around the nipples of my quivering breasts. As I surveyed my body, I found that somehow I could see myself from all sides at once. I watched one of Durga's hands pumping into my open, wet pussy, while a pair of her palms worked the backs of my thighs, and another hand added fire at my swollen love button. My excitement mounted when I realized that yet another hand played at the opening of my anus.

I wanted more. As I shifted down, forcing her fingers deeper inside my cunt, I saw her tenth hand disappear between her own legs. I reached for that hand, drew the fingers away from her cunt, and sucked the juices from them slowly. The taste of her, salty and sweet, inflamed me further. I cupped her furry love mound with one hand, then dipped my fingers into the wet inside. Her clit throbbed under my fingers. She moaned softly and rocked her hips toward me

all the while working my body into a frenzy with her hands. I could stand no more. I gasped for air. My whole being shook. A release that I never imagined possible washed over me. My body was both expanding and contracting at the same time.

Durga encircled me in her arms until my shaking subsided. I held one of her hands in both of mine. I took the fingers that had been inside me into my mouth and licked and sucked. She rubbed my bottom and continued to fuck my hungry mouth. She lay me down on my stomach. I opened to her and she slid inside my asshole. She wiggled her finger and set shocks of delight throughout my system. I raised my hips to meet her hand and bucked against her fingers.

"Gently," the Goddess said.

"More," I pleaded. I climbed to all fours and she leaned over me, her hot breasts resting on my back, her beautiful hand penetrating the dark of my shithole. I ground myself against her. All too soon I was panting, twitching, howling. My ears began to ring. My face and my whole body flushed. Convulsing, I collapsed to the floor, my pussy fluttering. Durga's hands patted my back. The exhaustion that I had expected to overtake me did not come. Despite, or perhaps because of, the expenditure of energy I was filled with strength.

I gazed up at my Goddess. She grinned when my hands glided between her thighs. She knelt in front of me, knees wide, and I buried my tongue in her tasty wetness. I lapped her juices, sucked her clit, and slid my tongue deep, where I felt her ripples of pleasure. She came in a gush. I drank her in, gulping and struggling to breath.

She lay down next to me, squeezed me tight. Her hands fixed my hair, traced the bones of my face, ran a feather along the outline of my lips.

"This will not happen again," she said and I detected a note of reluctance in her voice, "but know that I am with you always." She rose to her feet.

I struggled to sit up, to reach out, to call her name, but found I could not move. My eyelids dropped closed.

What seemed like moments later, I woke with a start. A two-foot Durga stood unmoving against the wall of my bedroom. Her eyes shone brightly. I followed her gaze to where the phonebook lay on the floor. I turned to locksmiths, called, and arranged to have my locks changed that afternoon.

Stretching out on the floor to wait for the locksmith, my hand brushed something soft. I rolled over and found one of the Goddess's feathers. Opening my precious locket, I thought I felt a pulse in the warm metal. I removed the lock of Sheila's hair and slipped the yellow feather inside.

Judy T. Silver

Honor Restored

The speaker stopped and gasped when she felt a smooth, young hand wander up her thigh. She glared into Daac's eyes, a response which would have quelled the disobedience of any other trained tawen, yet Daac continued, her hand straying to the Sheran's breast. A guest smiled. Daac drained the rest of her wineglass and poured herself another. She set the glass down and let her hands stray between the horrified guest's legs. She leaned over the woman and was about to kiss her.

"Daac!" Nacia's voice sliced the air like a razor as she drew a whip from her belted black tunic. "Cease this indecent behavior now!"

Daac slid her languid hand up under the Sheran's tunic, touching the guest's womanhood. Picking up her glass, Daac slithered away and moved to a second Sheran. The woman lost her composure and shrank from her in fear and confusion as Daac, a lowly tawen, violated her as well.

The Sherans seemed unable to respond. Their shock was so great they were left dumbfounded and helpless. Accustomed to docile, obedient tawens who existed only for a Sheran's pleasure, all eyes were on the insolent anomaly dressed in a diaphanous crimson tunic.

No one on Omron had ever seen such a flouting of tradition. The Simacs were a people for whom protocol and honor were held above all else. They were an inscrutable people, controlled and restrained. Emotion was an anathema to Simacs and public displays of passion were considered vulgar. Daac's behavior was outrageous beyond all comprehension.

The guests had tried not to respond in deference to their hostess's reputation, but Nacia could no longer control her tawen's behavior. Being a tawen to a great Sheran like Nacia was an honor among the Simac people, but Daac was certainly not treating her position as an honor.

Nacia had never seen Daac behave in such a way and was humiliated and infuriated beyond words. As the silence in the room lifted, Nacia could hear the buzzing and whispering of displeasure and outrage. As Nacia thought about what to do, her tawen walked about the room gazing seductively at the Sherans, who still tried to ignore her.

"Have you ever seen a tawen take such liberties with her Sheran? Where is her training, her pride?" one outraged Sheran asked of another.

The other Sheran responded, "I saw her putting her hands on her Sheran's bare legs. She even touched her breasts. It's as though she weren't a tawen at all ... Oh..." Yet another Sheran was molested by the salacious creature who was making a mockery of the Simac's sacred tradition of honor.

A whistle followed by a thundercrack filled the room as the whip fell on the gratkah, the errant tawen. Nacia had regained her composure and, despite her shocked guests, was responding in true Sheran manner. One stroke, then another and another tore at the slave's back. Streaks of lightning left tracks of red. Harder and harder the whip fell, but Daac did not respond. At last she turned and looked at her Sheran as though at a stinging mosquito. In her eyes was a glazed look of bewilderment. She did not know why her

Sheran had been angered. Daac felt only a warm, glowing feeling through her entire body.

When the whipping stopped, the tawen's mind felt as though it had been wrapped in cotton. She didn't mind a bit as she twirled about the room, stopping on occasion to stroke the soft, smooth skin of the guests, only one of whom did not recoil in disgust, but smiled instead.

Nacia could feel beads of perspiration on her face, beads of humiliation and anger. She tried to tell herself this was not happening. As she looked at her tawen destroying her reputation and outraging her guests, she knew it was happening. She watched, horrified, as her tawen nearly spilled her drink on one of the elder Sherans. The sedate, silver-haired woman gasped in horror. "Gratkah!" She barked the epithet at Daac as she shoved her hand away. Daac struggled to keep her balance and maintain her hold on her wineglass from which she greedily sipped.

"Come with me, gratkah!" Nacia hissed into Daac's ear as she dragged the tawen from the room by her silver collar. She looked into her tawen's eyes and saw nothing, no remorse, no fear, nothing. Furious, Nacia slapped Daac's face hard, but there was no response. Nacia was frightened and angry as she shoved Daac into a small windowless room. She locked the door, dreading the prospect of facing her guests.

"My guests, my friends," Nacia began, wringing her hands and licking her suddenly very dry lips, "I have no explanation, no apology, no excuses. I have never seen my tawen behave in such a way. She has violated all precepts of the Simac people ... I ... I ... can only promise you that I shall have her in the square at noon tomorrow ... and if more satisfaction is desired by any of you whom my despicable gratkah violated, it will be yours."

Nacia turned her head for a moment to wipe an escaping tear of angry sadness before turning back to her guests with

her usual calm and equanimity. She stood, a stoic smile pasted on her ashen face, wishing her guests a pleasant good night.

ॐ

When her last guests were gone, Nacia closed the door and leaned against it. She walked across the parlor and collapsed onto one of her couches. The forced smile gone, the choked-back tears appeared. Nacia dropped her head into her hands, her rich red hair covering her face. *This debacle might even cost me the seat in the ruling council. I've wanted it so long. There are so many changes that need to be made. Until tonight, I had my friends' support, but now it appears that Ashola's chances for that seat are far greater than mine.* Ashola, whom she had invited to the gathering in the hope that they might reach some compromise in their rivalry. But instead Nacia feared she had just shown Ashola her worst side.

Nacia sat in the dark salon, staring into empty space. She sat there many minutes, her focus on the locked door behind which her tawen lay—singing. Singing? *Has this gratkah no shame, no remorse, not even fear? How can she be singing? She knows what will happen tomorrow.*

Nacia was confused and weary. She was torn between love and honor and felt betrayed by the urchin she had taken from the streets. How could Daac cast aside all the years of training, discipline and love, and why?

Nacia had been drawn to the young urchin's innocent beauty and her dark, haunting features. Daac's long black hair cascaded down her slim back. *She'd had such a terrible life and was so grateful to me for rescuing her. Her tears were so beautiful as she fell at my feet begging me to take her. After all this time, I thought I had trained her. She was to be my consort when I became a member of the ruling council. Now*

it seems that both the seat on the ruling council and her fitness are just a fantasy.

Daac lay on a mat in the tiny room, staring at the silver ceiling overhead, idly toying with the glass she still had with her. Within it she saw a rainbow of colors. She sipped from the glass, distracting herself by wondering what she had done to be exiled to the punishment room. It really did not bother her that she was there. Nothing bothered her. In fact, she had never known such mellow comfort. The peace she felt welled up in her and expressed itself in song. Daac rose to her feet and twirled around the room, her long black hair whipping around her face.

> *A proud and mighty people rise,*
> *defeat their foes, collect their prize,*
> *the prize of freedom, fiery eyes.*
> *To any enemy or foe who dare*
> *undermine the Simac code.*
> *Sheran and tawen,*
> *two as one.*
> *Joint symbiotes as the dual suns.*
> *Each incomplete without the other.*
> *Rhana, Ghoshi, eternal lovers.*

Daac had sung that song since she was a child. She sang it when she was hungry, she sang it when she was lonely, she sang it when she was scared. She never dared to dream that someday she would be a part of a joint symbiote. "Sheran Nacia," Daac whispered aloud as though it were a prayer, "Sheran Nacia, you're so beautiful, so imperious, so ... I don't know ... I love your thick red hair when it billows around your shoulders. You were the most exquisite being

I'd ever seen. You heard me singing and spoke to me. You spoke to me. I was nothing then, but you were so kind." Tears welled in the corners of Daac's eyes, and her glowing, mellow feelings faded as she felt a strange deep sadness clouding her mind.

Dark images appeared in her mind. Guests in the salon. Sheran Nacia angry, swinging a whip ... Daac dancing before a roomful of shocked Sherans ... The feeling of forbidden, smooth, soft skin ... The heady taste of wine...

Daac stopped dancing, her mind now focused and clear. It was all true. The images were real. Horrified, she now knew why she had been put in the punishment room. *What could ever have made me behave like that? I betrayed and humiliated my Sheran, my beloved Sheran. I don't even know why. Will she throw me back onto the streets again? It's what I deserve. Will I be taken to the punishment post? Will I even survive?* She shivered in fear, remembering her hungry years on the streets; of being used by Sherans for a meal or a night's shelter. She shuddered as her tears became sobs that coursed through her body.

The stars were fading from the sky when Nacia finally rose from the couch. She had had only a brief and fitful sleep that endless night. Now she walked to the door of the locked room and inserted the key. Daac heard the key in the lock. When she saw the door opening, the tawen dropped to her knees, her head to the floor. She grabbed at her Sheran's knees and groveled in desperation. Daac wept, begging forgiveness.

Nacia was both startled and pained. This was not the same insolent gratkah who had betrayed her the previous night. This was her beloved tawen. Honor battled love as Nacia agonized. She knew that for the honor of both her

tawen and herself the punishment must occur, but she longed to wish it away, to have things as they were before the terrible party.

Nacia felt her tawen's desperate touch and the wet face pressed against her bare calf. The Sheran longed to lift her tawen to her feet and hold her warm, smooth body. She longed to lift Daac in her arms and place her in her bed. Daac's softness and sweetness called to her, but she could not respond. As she stood there agonizing, a quiet corner of her brain noticed the nearly empty wineglass. The liquid was bluish in color in the early-morning light.

Nacia shook Daac from her leg as though her tawen were a small animal. The Sheran straightened and stood as dispassionately as she could over the sobbing girl. Holding back her own tears, Nacia stripped Daac of her short, silky tunic. She attached a leash to her tawen's collar, leaving her sobbing and naked as Nacia went to dress herself.

By Simac tradition, the tawen must be taken naked to the punishment post when the suns were just above the crystal tower. Also, by tradition, the Sheran must dress in her most exquisite finery so that there would be a stark contrast between herself and her disgraced graktah.

Nacia was nervous as she dressed. *I've witnessed hundreds of public punishments but never administered one.* She stepped into the long, black gown trimmed in silver. *Perhaps it is a defect in my training, the public punishments have always disturbed me.* Nacia knew that she would have to bind her errant slave to the punishment post and publicly invite any whom her tawen might have offended to punish her. With a shock, Nacia realized that this might include her entire guest list. *I've never seen a punishment given by that many Sherans. Will my Daac even survive? I am being foolish,* Nacia decided. *I must fulfill my duty and restore both my honor and Daac's. She will be all right.* Nacia could not

remove from her mind the image of Daac hanging limp and lifeless from the punishment post.

"Sheran Nacia, a miserable tawen begs to speak."

"Speak, tawen." Nacia controlled the tremor in her voice.

"Sheran Nacia, a miserable tawen feels ill in head and stomach. The room spins, my heart races."

"Nonsense, tawen. It is nothing but fear ... and you have reason to be afraid." Nacia hoped her sharp tone hid the concern she felt. She picked up the wineglass containing the blue liquid. Nacia looked from it to her exhausted tawen. Daac's beautiful face was drawn and haggard, lined with illness and terror. She lay quiet on her mat, hardly daring to look at her Sheran. Nacia felt a wave of great love and pride as she looked at the shivering girl. Despite her illness, Daac had not even attempted to avoid her punishment. Nacia sighed, left the room and closed the door behind her.

She furrowed her brow as she looked into the glass she had taken from the little room. *That was no trick of the light. This liquid is blue, and these crystals...*

How can I go through with this now? But I must.

Daac had been silent since she had complained to her Sheran of feeling ill. Something in her Sheran's response frightened Daac, who was certain that her illness was not simple fear. *Sheran Nacia didn't think so either. Why'd she say what she did? Why did I do those terrible things last night. Oh beloved twin goddesses, what's happening to me. Please be with me.*

O Twin Goddesses, Symbiotes and mothers of us all, Sherans and tawens, help me, give me the courage and strength to endure my punishment. Soften my Sheran's heart, O Rhana, Great Sheran. As you have compassion for your Great Tawen, Ghoshi, let Sheran Nacia have compassion for me. Daac knelt before her altar to the goddesses, tears

streaming down her face, her heart filled with fear and self-loathing. "As you, Sheran Rhana, forgave Ghoshi, so let Sheran Nacia forgive this undeserving tawen." Daac shuddered at the terrible thought that if Sheran Nacia did not forgive her, only the streets would await her.

"It is time, tawen." Nacia steadied her voice as she attached the leash to Daac's collar. The final part of the ritual was Nacia's drawing of Daac's hair off her shoulders and piling it atop her head in the fashion of a gratkah. A wide scarlet ribbon wound around the piled hair left no room for doubt of Daac's position. The tawen wept in silence as she endured the humiliation of having her shoulders bared. A tawen's shoulders were only bared for punishment. She dropped her head when Nacia had finished, burying it in her hands.

Nacia swallowed hard and gave a short tug on Daac's leash, leading her tawen out the door and onto the street. Their walk to the square was short but not without incident. Bystanders, mostly other tawen, hurled epithets and overripe fruit at Daac as she walked, naked and unprotected. The tawen tried to dodge the juicy gespas that burst on contact with her body. The tawen's skin itched from the sticky blue juice trickling between her breasts and down her legs. The heat from the twin suns added to Daac's already miserable state. *Will this ever be over,* her mind screamed as her head throbbed and her stomach roiled.

By the time Nacia and Daac arrived at the square, Daac's golden skin had turned to a grayish blue, as juice and perspiration commingled and trickled down her body. The itching and misery was unbearable and the punishment had yet to begin.

Nacia, for her part, wasn't certain she could even go through with the punishment. Her tawen had already suf-

fered and perhaps for naught. Seized by a wave of compassion, Nacia lifted the hem of her fine gown and wiped some of the sticky juice off of her tawen's back. She knew that the whip would be much more painful on a wet back. Nacia's actions did not go unnoticed. Sherans whispered among themselves, wondering what this show of leniency before a punishment could mean. It was questionable behavior at best.

Taking a few deep breaths and swallowing her doubt, Nacia reminded herself her honor was at stake and led her tawen to the post. She bound Daac's wrists together and locked them to a ring at the top of the post. The tawen was forced onto her toes. She was bound in no other way so that her body would be free to twist and turn, allowing all parts of her body to feel the whip.

A large crowd had already assembled, larger than normally expected at a public punishment because they were about to witness the punishment of Sheran Nacia's tawen. Everyone in the assembled crowd knew of Nacia's hopes of one day ruling the Simac people. They knew too that her gratkah's behavior could destroy Sheran Nacia's chances forever.

Nacia left Daac at the post and walked back to the crowd in time to see her guests of the previous evening, each with whip, cane, or gikkarat in hand. She shivered when she saw the gikkarats. *I can't help myself, I feel such hatred for the sharp-edged metalian whip. I've seen it slice through the skin of too many tawens. If the goddesses should bless me with a seat on the ruling council, I will outlaw the wretched weapon, for that is what it is.* Nacia knew that the gikkarat would be used on Daac's soft, sweet skin. She longed to turn away, but knew she must watch or be ridiculed by her peers.

Nacia looked at her tawen, nearly suspended, bound to the post, and tears came to her eyes. Daac twisted her body

enough to see her Sheran, who rewarded her with a soft smile. Daac's terror lessened. She still had the love of her Sheran—or so she hoped.

The crowd became silent as the first of Daac's guests stepped up, whip in hand, and took aim. The twelve-foot whip whistled eerily, breaking the silence and landing with a loud crack on the tawen's back. Another stroke fell like lightning. Stroke after stroke fell. Daac was silent at first, then she moaned. The moans turned to cries and then to screams by the time the fourth guest had had her turn. Each guest was limited to ten strokes, Nacia knew, but that still left forty more strokes, and twenty of those with the gikkarat.

This is barbaric. I should be the one to punish my tawen. Only a Sheran, only a tawen's Sheran should be permitted to discipline her. If I ever get that seat, I swear to the goddesses I will make changes. Nacia was suffering the pain of her tawen.

When the time came for the gikkarat, Nacia held her breath. Would Daac be able to endure the ordeal? She had been under the gikkarat only once before and that had only been a demonstration.

Daac turned at the sudden silence in the crowd and found its cause. The suns reflected off of the metalian fronds of her worst nightmare. Her heart sped up and her mind turned to water as her legs became jelly. *I'll never survive this, I can't take any more, O Goddesses, have mercy on a miserable tawen. Help me.*

The tawen's prayer disappeared in the ocean of pain that threatened to drown her. A second stroke sliced through her back, and a third across her breasts as she was spun around. She could feel the blood on her back and breasts mixing with the now-dried juice and the ever-present perspiration. Daac's mind faded, racing away from the pain to anywhere else, back to the events of the night before, but her memories hurt almost as much as the gikkarat.

Beyond the previous night, back to happier times with Sheran Nacia, Daac traveled, transcending the pain, turning it to love. *I couldn't live without her—it's not the streets, it's being without her. No. No, no...*

Then there was silence. There were no more cracks. No more slicing of her skin. All was still. Daac twisted her tortured body, squinting through sweat-filled eyes, to see what had happened. Officials were conferring. Elegantly dressed Sherans were all gathered together. Daac could not hear what they were saying. She was simply grateful for the respite whatever its reason.

The final Sheran walked up to take her turn with a gikkarat. It was Ashola, who hoped to rival Nacia for the council seat. Nacia knew this might give Ashola an advantage, but thinking of her tawen's already bloody skin, she knew she could not let Ashola wield the harsh instrument. Nacia rose to her feet and grabbed hold of Ashola's whipping arm. "The gikkarat is brutal, barbaric. It is a weapon of violence, not an instrument of discipline. My tawen has already endured ten strokes from it. Ten more will kill her. She is not yours to kill."

Nacia appealed to the Katima of the ruling council for leniency. The Katima was astounded at what she heard. No one had ever before protested on behalf of a tawen or against the use of the gikkarat. The Katima was amazed, yet pleased. *For years, I have secretly hoped the gikkarat would pass out of fashion, but it becomes more popular with time. I am only an old woman now, a figurehead. I am helpless. The council goes on without me ... This brazen young Sheran would be a very fine Katima. Perhaps someday...*

"...Sheran Katima, we need your decision now." The voice was urgent, with a note of impatience. With increasing frequency the Katima would drift into her thoughts. The coun-

cil was frustrated and hoped for the day of a new Katima.

"...Sheran Katima!" The elegant silver-haired crone looked up. "Oh yes ... my decision is that there will be no further use of the gikkarat on this tawen today." A loud murmur passed through the crowd at the strange ruling.

From her place at the post, Daac did not hear her Sheran plead for leniency. Daac knew nothing of her Sheran's feelings. Daac knew only that Sheran Nacia was to be the last to punish her and that her Sheran's punishment would be the most significant, because when it was finished, her Sheran would have three choices. She could drop the whip and release her tawen, reclaiming her. That rarely happened. The second choice was the most common, and that was to continue whipping the tawen until she lost consciousness, then she would be released and the healers would help the tawen recover. In both cases the honor of the Sheran and the tawen would be restored.

The third choice terrified Daac. The Sheran could, if she chose, continue to hold the whip and walk away, leaving her tawen to the mercy of the crowd. Often there was no mercy and the now-dishonored, disowned gratkah-tawen would be left at the post for hours until someone took pity and released her to the streets.

Still holding Ashola's arm, Nacia breathed a sigh of relief and released her grip. She turned to the crowd. *Let them know the truth.* "My tawen should never have been punished today. Her actions were not under her control. She was drugged the night of my gathering."

Ashola, the woman holding the gikkarat, spoke up, her voice full of scorn. "This is all a ploy to avoid the punishment. There was no zingarad in that glass." To the crowd she said, "Nacia cannot bear for her tawen to feel pain; she is as weak as her tawen and would rather lose her honor than allow her tawen to be marked."

The word "zingarad" was on the lips of everyone in the crowd. It was a powerful drug, outlawed because it produced a complete lack of control, which the stoic, disciplined Simacs would not tolerate. "I never said 'zingarad,'" Nacia called out in a loud, strong voice. "Nor did I even mention a glass." Her voice now thundered through the square as her anger rose. She glared at Ashola. "Only the person responsible for committing this crime would have known about the things you just said. I knew you wanted the seat on the ruling council, but I never imagined the lengths to which you would go to attain it."

The crowd was angry now, for although the Simac were a severe people, they were a just and honest people and Ashola had committed an intolerable act.

"If you believe this to be true, why did you let the punishment take place?" Ashola tried desperately to deny her actions.

"Honor must be upheld regardless of circumstances," Nacia replied in a tired voice, aware of what her honor had cost her tawen.

The crowd could not be contained as they surrounded Ashola and dragged her to the Katima's throne. Nacia no longer cared what happened to Ashola; she turned her full attention to the figure at the post. Nacia sighed. She would do this for honor, but that would be the only reason. *Sometimes, it seems honor demands too much.*

Daac could not erase the image of abandoned slaves locked to the post as their Sherans walked away holding the whip. She was so consumed with pain, fear, and heat, she never heard her Sheran's announcement to the crowd. She never heard that she had been drugged.

After the gikkarat, the whip was a caress across her back. She knew who wielded the whip. Just from the placement and feel, Daac could recognize her Sheran's hand. *My Sheran*

can always turn the whip into an instrument of love, but does she still love me? Daac could scarcely breathe. She had often felt her Sheran's whip kiss her body, caress it, produce not pain but sweet, intense pleasure. The strokes became harder but still not beyond Daac's limits. Her pain was in her mind, not in her body. It was the pain of uncertainty. Would her Sheran walk away?

Daac wept. She sobbed. Great wracking sobs shook her body as tears coursed like a river down her face and onto her breasts. She did not cry because of the whip. She cried because something raw and sore had opened in her. She cried for the life she had had before Sheran Nacia, for the day her mother had sent her out to the streets because there was not enough money to feed the whole family and she was the oldest. She cried for her years of begging and groveling. Most of all she cried at the prospect of returning to that existence.

Daac's immersion in her misery was so complete, she was barely aware that the whipping had stopped, that her Sheran had dropped the whip. "Tawen, dearest tawen, it is over. It is over." Nacia released her tawen. Lifting Daac in her arms, she called for the healers.

It took more than a moment for Daac to realize she was not to be abandoned, left naked and alone. She looked at her Sheran and saw pain in her eyes, pain she didn't understand.

Nacia could no longer hold back her tears. "Honor be damned. I've paid my homage to honor," she whispered as she let her tears flow and pressed her wet face against her tawen's wet and sticky face. The tears of the two women mixed. For that moment, indeed, they were just two women, two women who loved each other.

In the transport, under the care of healers, Daac recovered. She tried to clear her pain-fogged brain, tried to

remember where she was, and then she forced herself to focus. Only inches away, her Sheran's beautiful warm eyes looked back at her. "Welcome back, tawen, I've missed you."

Daac wasn't certain if she was awake or dreaming. It was her Sheran's voice. Her Sheran's eyes. Was it really over? Was she really going home? The entire horrible day faded as she lost herself in her Sheran's eyes. Nacia looked lovingly at her tawen, her trusting, devoted, precious Daac. "Let's go home, Daac, my love. Let's go home."

The crowd began to disperse as the medical transport lifted into the air. One lone figure remained, even after the transport was no longer visible from the square. No one had noticed the young girl, still in braids and not yet of the age when she must honor protocol. She tried to make sense of all she had seen. She walked up to the post and recoiled from it. She approached it once more and reached out her hand. She touched the post and looked at it intently. She looked at the ring on top of it, at its gleaming, unmarred surface. The post would keep its secrets; nothing showed of the pain of countless tawens.

The young girl loved her world, yet it frightened her. She looked around at the gleaming silver buildings, the city pristine and correct. She looked up at the tall, lush blue trees that lessened the intense heat of the suns. She glanced back at the post and sighed, shaking her head at all she could not understand.

Bernadette Lynn Bosky

None of the Above

I stood in front of the mirror, trying to decide whether to apply my body makeup now or when I arrived at the party. A breeze came in from the open window, cool on my moist skin. My bush was still wet from the shower, too; small droplets of water clung to the hairs, sparkling like small jewels. I couldn't bring that effect to the party with me, I thought, but—I reached for the edible glitter, as well as the nipple rouge and flavored labia gloss. Better to doll myself up now and be prepared. I'd heard that sometimes, at parties like this, you might not make it past the front hall before your clothes came off—often with more than a little help. Besides, why not apply the lotion and makeup while I had time to fully enjoy it?

I touched my breasts briefly in anticipation. The prospect of the party had already excited me, and my nipples hardened surprisingly quickly. As I finished drying myself, I relished the immaculate feeling of the soft cotton towel. Its touch was dry and clean, strangely intimate in places that few human lovers ever touched. Was I already preparing myself, thinking in terms of such radically different eroticism? The combination of excitement and mystery was almost staggering. By the time I set down the towel, my nipples

were tingling, and my bush was beginning to moisten again.

"Business before pleasure," I told myself. First the glitter, to allow it time to set. I took down a small silver pot, then paused; finally, I took down the metallic blue as well, to match my garter belt and camisole. I remembered shopping for them the day my invitation had arrived: they'd cost two weeks' salary, but I had no regrets. People who can't afford clothes like that just don't get invited to body-morph parties, let alone something as rare as this. It was fun to pretend that I was one of the salary elite, even though I really wasn't.

I still wasn't sure how I got invited to Kikito's party, although I wasn't complaining. She knew me casually from volunteer hours at the medical co-op, but we hardly spoke. Apart from the obvious differences in social class, she seemed temperamentally quiet and withdrawn, so I didn't push it. I had no idea I'd made an impression until her card arrived, complete with foil-base holo-print and delivered by personal drone. When I saw what the invitation was for, I was even more impressed. And not a little scared, but most of all excited.

Well, I thought, *if it's my body she wants, here it is—all of it, all ready for action.* I scooped a dab of glitter with my fingertips. Then, slowly and smoothly, working from the armpits in and the cleavage out, I applied it: silver to highlight the large, pale globes of my breasts, blue to emphasize the valley between them. Just a hint of silver to show provocatively above the collar of my duster. The round, repetitive strokes were like a massage, not quite sexual but almost hypnotically sensuous. *Good tits,* I thought. I used to think they were my only good feature, but things had certainly changed in the past few decades. As the glitter set, it began to spread its delicious warmth through my skin.

Taking more silver glitter, I drew a dramatic horizontal slash across the full expanse of my belly, like the trail of a

shooting star. Just a drop of blue, to highlight my navel, and I was finished. I imagined strangers stroking the soft pillars of my thighs or the hills of my hips and ass, resting on my round, cushiony belly and breasts. Here I was, all curves and dimples and tender white skin, and all of my flesh was wanted—even lusted for—at what was probably the sexiest party of the year.

How things change, I thought. Science could keep us young and healthy, no matter what our shape. But with the advent of AIDS and crack, being thin began to carry a far different message than it used to, and people like me reaped the benefits. Now there was the immuno shot, but crack had been superseded by whiz and glacier, and thinness was less likely to mean diet spas, more likely to mean your food credit had run out. There was some talk about optimum body-weight adjustment, but—like the talk of an oral-dose spermicide since the invention of the vas-valve—no one really cared anymore.

I rubbed the last of the gel off my fingers, knowing where I'd put those fingers next. I never was good at delaying gratification. The deep heat in my breasts and belly demanded an answering heat between my legs, and I trailed my fingers down to play teasingly in the curls down there. I traced the rim of my dewy inner lips, imagining alien limbs touching me. The warm tingle of the hardening glitter-gel heightened my awareness, but altered it—what living surfaces could rub against mine to excite me in the same way? As I fingered myself, I closed my eyes and thought of orifices opening and closing on my nipples—or my toes, or ears. I rubbed my clitoris, wondering how sex would be if it could taste, or hear, as well as feel. I thought about orgasming in colors or smells. I imagined the unimaginable, because that was what this party was all about. When I came, I screamed, and for a moment it sounded like someone else.

None of the Above 145

By the time I'd applied the rest of my makeup and slipped into my soon-to-be-discarded clothes, it was almost time to go. I'd decorated the soft bulge above my stockings with stik-on jewels, and I could both feel and hear them swish against my skirt as I walked. I pulled on my coat and hood, giving myself one last look in the subhall mirror. I'd probably overglitzed myself, revealing myself as the poor little sub-managerial I am, but what the hey. I knew that nobody would be looking at me that intensely anyway. Not with the two Hiyo there.

It seemed like a dream, but there it was, in holo-foil. Kikito had listed the two Hiyo as hosts, rather than guests of honor, which meant that they would be active participants in the party rather than observers. I knew some people who would kill to have sex with a Hiyo; gossip was that some people had, and that the Hiyo found it uproariously funny. Yet the nature of the Hiyo, as revealed in sex, was said to be tender, searching, patient, and literally empathic. No one could explain this contradiction. No one could explain anything about them. They were just infinitely, literally alien.

For a number of reasons, the Hiyo had been rumors long before they had become news. First contact may have come years before even the first tentative newsleak about an alien species on earth. Were the powers-that-lead-us trying to determine if contact was safe? Or, once the Hiyo had made their first immodest proposals, had the higher-ups not wanted to share a good thing? One story was that the first leak came from a jealous wife, but that was poppycock, since there's no reason that she couldn't have joined in too. More likely, the Hiyo began to insist on more variety, and so the knowledge of their existence spread. Still, most people were too embarrassed to make the Hiyo bignews. Scientists blushed at the Hiyo's reactions to the most impersonal probes and analysis, and even afternoon talk-show hosts

hesitated to ask how the Hiyo ate, or washed, or prepared for bed.

And here I was, going to a body-morph party at which the two "hosts" were Hiyo-ba and Hiyo-ka, the first two of their kind to land on our planet and mingle. I had no idea how Kikito rated. She was rich, but probably not that rich, and I knew she had never held office. Still, the address for the party was an estate in a governmental trans-urb—maybe her mother or father could pull in some favors. Most of all, I was still astonished that I rated. I was ex-urb, I was sub-managerial, and I'd never had the slightest body-morphing done. On the other hand, I had lots of flesh and lots of desire to share it. Some people say that the Hiyo have a kind of sixth sense that reads sexual appetite or life energy, regardless of distance and without any direct contact—who knows? All we really knew about them is that we didn't know anything.

Again, I felt a fear that was really more anticipation. I thought about how rare it is for adults to experience something totally, radically new. I'd heard these parties described as losing your virginity all over again, but I knew it was even more than that, even more unimaginable.

The person who answered the door was clearly male, severely morphed toward some indeterminate species. His odor was powerful, and small rows of spikes strained up against the fabric of his satiny briefs. Ferret? Cat? His face was furred, but scales ran down his impressively broad back; his abdomen was large and sculptured. That much work couldn't have been done in fewer than three operations, and it must have been expensive. But from his deferential manner, it was clear that he hadn't paid to have it done. He ushered me inside, the perfect blend of hired help, status

item, and conversation piece. I thought about those spikes on his penis and wondered if his tongue had been morphed as well. Maybe I'd get a chance to find out later, I thought. First, I'd look for Kikito. And the "hosts."

More guests were looking at me than I had expected, and all of the looks seemed to be approving. I, on the other hand, was trying not to gawk, while taking in as much of the wild parade as possible. First I focused on the surroundings: shockingly large rooms with an eclectic blend of high-state fixtures and expensively retro furnishings. One room had a four-wall ForRest-Seen, but was furnished in antique chrome and glass. The people, as I had expected, were even more impressive. After dozens of seemingly disinterested glimpses out of the corner of my eye—horned shoulders or magenta buttocks here, a flash of extended membranes there—I at least trusted myself to view my fellow partiers head-on.

It was one thing to see the self-shaped salary elite in restaurants as I passed, or behind the darkened windows of purring vehicles, and another to be so close that my breath stirred the feathers and fronds on their cheeks or forehead. One person touched me with delicate, feminine hands, pulling my fingers down to a leathery flap in per abdomen; when I lifted the flap out of the way, a huge, deep purple cock reared up, larger than my forearm. "Too much for you," the person said and laughed. It was half comment and half question; I just nodded and smiled. My new acquaintance smiled back and walked on, heading for a mouth-morphed woman I'd noticed earlier. *Good choice,* I thought, imagining the oral sex they'd have.

A few moments later I noticed another natural like myself. I have to admit that I was relieved, though also ashamed of my relief. Maybe I was more isolated, off in ex-urbia, than I had thought. I could overlook or accept small changes like Kikito's, but the morphing here left me overwhelmed and

exhausted. I'd often looked down on holy-rollie preachers who ranted on about the unnaturalness of body-morphing, re-creating humans in the image of our own whims. Yet here I was, happy beyond words to see someone whose face and body even remotely resembled mine. And call me cynical, but my guess was that the desire and arousal I also felt didn't make me any different from the holy-rollies, either.

Finally, I realized that I'd been doing something I'd successfully avoided until then: staring. The fellow natural, a blonde, golden-skinned woman about my height and size, didn't seem to mind. Her dress was surprisingly modest, yards and yards of a plain, heavy fabric, buttoned from navel height to right under her chin. But it was trimmed in what appeared to be real alligator leather, so I guess she expected to be gaped at. The licenses don't come cheap; and if she could bribe her way around the lack of a license, she was even more credit-heavy.

"Are you looking for someone?" she asked me.

"I'm looking for the hostess," I replied, and then stopped. The woman raised one eyebrow, showing that she'd noticed my mistake. I hoped she realized what my intention had been. "I met Kikito doing hours at the med co-op, and I don't know anyone else here," I said to clarify whom I'd meant. It was one thing to mistakenly refer to Kikito as the hostess, far worse if I'd used a gendered pronoun for the Hiyo.

"So you're the one she keeps talking about," the woman said, putting her arm around my shoulder and smiling at me. I smiled back, happy that she had whisked us past my clumsy opening. Her breath was very sweet and smelled slightly of violets. Probably the glands had been engineered, but it was hard to tell. "I'm Pie," she said, as if that ought to mean something to me. I was still assimilating the idea that Kikito talked about me—or that the quiet,

elegant woman "kept talking" at all, as far as that goes.

"Y'know," the blonde said. "Pie. Kikito's my birth sister. On our mother's side."

Kikito had, of course, never said anything to me about a sister. But the more I looked at Pie, the more resemblance I saw, despite the obvious differences. Kikito was taller, muscular, and almost slender, though still roundly female and huggable-looking. Still, she and Pie shared the same lush mouth and the same cleft chin. Pie's face would have been shaped very differently, but Kikito's air-gills—her only body-morphing, or at least the only one visible in public—gave her the same round look as Pie's natural contours. Mostly, I saw the similarity in their eyes. Kikito's were round and as dark as her skin, while Pie's were oblique and ice green, but both sisters shared the same expression, at once wistful and playful.

"Does she really?" I said.

"Does who really what?" Pie replied, pulling me closer. I couldn't tell if she was kidding or not.

"Kikito," I said, somewhat thickly. "Does she talk about me? To you, I mean. I guess."

Pie cuddled against me until I could feel her flowery breath on my face. Her lips were a deep, almost bloody red, apparently without makeup—tattooed, maybe, or even engineered. I began to wonder just how "natural" she was, after all. On the other hand, she didn't seem to care that I wasn't morphed, and I found myself caring less and less that she might be. Under the voluminous dress, her round body felt solid yet giving, a comforting presence in my arms. *How strange and wonderful it feels,* I thought, *to hold a body this much like my own.*

"Oh, you're really my sister's type." Pie's voice grew even deeper and more musical; she half whispered, as though sharing a secret. "We fight over lovers all the time.

"Would you let me see what you have under there?" she said, pulling my skirt up with one hand and reaching out to stroke my leg with the other. Before I knew it, her hand rested warmly on my lower thigh. The feel of it through my stocking reminded me of my earlier fantasies: an interface of flesh and not-quite-flesh, textures unnervingly strange and exquisitely erotic. Then her hand climbed past my stik-on jewels, and it was flesh-on-flesh for sure. Very much. Indeed.

Well, I thought, *this is what I came here for.* In a way, Pie was as strange to me as a morpher would be, though of course not over-the-edge like the Hiyo. In her case, the strangeness came from familiarity: I'd never made love to a woman whose size and shape were this close to mine. I felt as though I were holding my exact breast and belly, hips and thighs and ass. As though my image had stepped out of the mirror while I had my orgasm and was meeting me here so we could do it again.

"You first," I whispered into her ear, past her thicket of gloriously blonde hair. I grazed her earlobe lightly with my teeth; in response, she moved closer.

I wanted to feel the texture of her skin, which I imagined would be much like mine: soft and smoothly dimpled, warm curves giving beneath my fingers. And most of all, I wanted to experience the protected triangle of her sex, to know if that was like mine too. Because of the thick fabric of her dress and the wide band of strategically placed leather, I could feel her general shape quite well, but these details were kept mysterious. As she no doubt intended.

"Are you sure you're ready?" Pie asked. "You know I'd hate to have you spoil the surprise too early..."

"No surprise to me," I said, nuzzling her neck. I opened the first two the buttons of her dress, bending down to kiss her chest and tits—

—and stopped, my eyes inches from the field of blue bumps that pulsed, ever so slightly, with each beat of her heart.

"No surprise, oh?"

Pie didn't seem offended, although it must have been clear that her skin was as awful to me as it was awe-inspiring. Maybe that's the reaction she wanted, or maybe she just didn't care. She smiled as I began to brush her skin lightly with my palm. Then she shuddered and arched her chest to my hand, taking in a sharp, deep breath. Clearly, her skin had been engineered for sensitivity as well as for exotic looks. The bumps were surprisingly soft—much like the skin I had expected, but textured in an intricate topography of hills and valleys.

I undid the next five buttons, and Pie's dress fell open to her navel. The bumps on her abdomen were much larger; from her waist down, they alternated with horizontal ridges, the same pale green as her eyes. I was amazed that I could have held her without knowing. But the thick fabric and full drape of the dress were clearly designed to make this possible.

Many people, I knew, would have found Pie's skin disgusting. On the other hand, many people would have been disgusted by her size and shape—our size and shape—only a few decades ago. My first reaction had been a matter of shock as much as anything else. An alien familiarity, familiar alienation—was this any more unnatural than age retardation, skin regeneration, or any of the dozens of procedures that were considered medical instead of morphing? And why was I here at this party, anyway?

"Oh, surprise, yes," I whispered, reaching back up to her exposed chest. I spread both of my hands out, cupping her flesh, massaging her skin with my thumbs.

She sighed and leaned toward me, increasing the pressure of my hands against the delicate tissue on her chest. I could feel her pulse. It reminded me of the warm, soft twitch of my own pussy, when I caress myself alone at night. Or maybe both reminded me of something else: the rhythm of an insect just out of the chrysalis, pumping its quivering wings in the sun. I thought of butterfly wings spread—as I sometimes spread my own labia to enjoy their velvety texture, as Pie's skin was spread before me, so naked and unashamed in the passion it was made for. As I stroked and held her, Pie's response was immediate. I could tell her pleasure from her breathing, the small sounds she made, and her movement under and into my hands. Her hips did not move, though mine began to, as I caught her excitement.

I bent down to kiss Pie's chest, no longer surprised at what I was doing. In addition to the salty taste I expected, her skin had a sweet, flowery flavor. Finally I placed it: the same violet tincture as her breath. I began licking Pie's skin. My tongue worked in broad, moist strokes across her breast-bone, then tickled the plump curve where her neck and shoulders joined.

Pie moaned for me to continue—maybe words, and maybe not. Whichever, her meaning was clear. She slumped toward me, and I could feel her body going even softer in my arms. I studied her face: round and golden and yearning, as beautiful as any sight I had ever seen. Her eyes were closed, her face tight with bliss and a growing need for release. Rubbing her extraordinary chest against the my own clothed softness, she tipped her head back and up, invitingly offering her mouth to mine.

We kissed deeply, matching our movements to each other's urges as though we could read minds. I knew that others at the party were probably watching, but I didn't

care. If anything, it made the whole experience even sweeter.

Her lips were hotter than any I had ever experienced—engineered for sure, I thought with what was left of my logical mind. I felt enveloped and inflamed, nurtured and hungry. Soon, I shut my eyes, and my awareness narrowed down to one throbbing beat: of her lips on mine, of her exquisitely embellished chest pressing against me, of my wet and hungry pussy.

As I was beginning to grow crazy for orgasm, it seemed that Pie was approaching hers. I was surprised, but pleased, especially for her: *If you can come just from necking,* I thought, *more power to you.* I rubbed and squeezed her nipples, which looked like alien, dark blue pebbles. That didn't do anything for Pie, though, and neither did stroking the paler, smoother surface of her breasts. She gently took my hand and replaced it on the hilly skin of her chest, without breaking our kiss. When she did pull her mouth away from mine, it was to whisper, more breathlessly than ever, "Lick me here again. Like you did. Please."

Pie's hands had worked their way up under my dress and were resting, tantalizingly, on my thigh and hip. There was a dancing light in her pale green eyes, and she smiled at me as I paused. It could hardly have been more clear: she knew what I wanted, but she wanted me to ask her, as she had asked me. She even played with my garter belt and panties, her fingers toying with the elastic and just barely avoiding contact with my pussy. Her own excitement grew more and more obvious. Finally, for one delicious moment, she touched the dewy outer lips; then her fingers withdrew again.

"Yes, please, touch me!" I called out, not caring who heard or what per reaction was.

"Yes!" she said, smiling, "—and we'll finish together."

Immediately, as though it were one movement, she plunged her hand into my underpants, and I began lapping and kissing and sucking her exotically sculptured skin. No wonder she had steered my hand from her nipples, when each blood-hot nodule was like a nipple, or more. I ground my hips against hers; she wriggled her torso under the stimulus from my tongue and lips. I held her tightly, as she played my pussy with a delicate yet expert touch. After teasing my labia, she began stroking my clitoris with her thumb—first gently, then more and more firmly. A deeper need had just begun to build in me when she satisfied it, plunging two fingers into my vagina. Riding her hand, I licked her flowery sweetness with more and more speed and enthusiasm.

It felt strange, yet somehow right—not cunnilingus, kissing, or nursing, but some combination of the three that was even more erotic. As I nuzzled and nipped, sucked and smooched, I could hear her whimpering into my ear.

"Suck me," she said.

And I did, sucking one node of her skin after another, always startling and satisfying her as I switched from place to place. Sometimes I used my tongue to tickle the valleys in between; usually, then, she would gasp, a soft ragged sound that made a shudder run through my own body.

When her orgasm started, she shoved her two fingers completely into me, and I began to climax too. I licked her throat, where the morphed skin faded into soft creaminess so much like mine; she moaned and shivered and almost screamed, working my pussy in the same rhythm as my mouth against her chest. I held her, my knees weak and my hips bucking uncontrollably. During my own release, I buried my face almost completely in her chest and shoulders, shouting my triumph into her hot, velvety skin. Afterward, she stood, panting and flushed. I clung to her, exhausted and

energized. I was ecstatic and speechless, changed in some way I couldn't define.

"So, are you enjoying the party so far?" she said.

We both started laughing. For a while, I was afraid that I wouldn't stop. I had worried so much—about the strangeness of the party, about the status of the others who'd be there—and the sex had happened too quickly for my feelings to catch up. As we laughed, she put one arm around me in a friendly hug: in some ways, that was as satisfying, and as much of a release, as the sex had been.

"Imagine what could have happened if we'd actually taken our clothes off!" I managed to say, before hooting with laughter again.

Pie looked at me oddly for a moment, as if she were trying to answer a question. Then her smile returned. I noticed once more how much her mouth reminded me of Kikito's.

"Oh, I don't think that would have made much difference," she said. Her tone of voice, like the look she had given me a moment earlier, was mysterious. While still affectionate, Pie's voice conveyed some kind of distance, as well. This bothered me, especially after the closeness of our post-finish laughter.

"I guess not," I said, mostly to be saying something. I wanted to prolong the intimacy we had had, or reinstate it. Finally I cuddled closer against Pie and said, "Do you want me to feel you again? Anywhere else?"

Pie's look was again unreadable: more mischievous than before, but maybe a bit sad as well.

"Sure," she said.

I kissed her, happy to have her strange, familiar lips back on mine. I quickly grew aroused again; my whole body tingled, especially where her abundant flesh pressed up against me. We kissed deeply and strongly, Pie running her fingers through my hair and pulling me even closer to her. If

she could finish like that from the skin of her torso, I thought—no matter how much morphed and sensitivity-engineered—imagine what she'll do when I feel her here. As I reached down into her dress, it suddenly occurred to me that her genitals could be morphed as well. Before I could wonder, however, I knew.

First, I discovered that she wore no briefs, just as she had worn no upper foundation. Thrilled and made bold by the freedom that gave me, I immediately reached further to stroke her pubic hair. And got the second surprise of this encounter: nothing.

Between per legs, Pie was as smooth and anonymous as a dress-up doll. For a moment, I held per featureless groin, hoping to cover for my astonishment. I was embarrassed, too; I didn't know if the cause was Pie's real nature or my own mistaken ideas about per. It was too late to try to remember if I'd spoken the pronouns aloud at any time, too late to undo any of the interior assumptions I'd made so naively. Time only to wonder how I could cover, and where we could go from here.

And a small moment to marvel that I'd already made sex with a transgender body-morph. Without knowing it at the time.

"Do you think I should have my skin done down there too?" my body-morphed partner said. Pie was trying to be gentle, but I felt as if every arrogant, shameful thought in my head was open and clear to per. I said nothing, though I did lean my head on per shoulder.

"That's such a common place, though, isn't it?" Pie continued. "And I don't think I need it. Do you?"

I snuggled up to per ample body more closely, enjoying the comfort and human warmth I found there. Our stature and size were so deceptively similar, yet for me that had become overshadowed by how different we were—as differ-

ent, I thought, as two humans could be. It was still tough for me to think of Pie as transgendered. I hugged her—no, per—full, yielding breasts and kissed per red lips. Then I gently traced the contours of her torso-skin with my fingers and felt myself smile.

"No," I said. "I don't think you need anything more. Not at all."

We kissed again; I put my arm around Pie and felt per relax beside me. In a moment, Pie started buttoning per dress. I helped her and couldn't keep from noticing the cloth—even thicker, with more concealing bulk and stiffness, than I had guessed.

"Yeah, well, I thought you might be surprised. In my job, all my clothes have to keep it subtle. Can't disturb the little ex-urb naturals I work with, y'know?"

I'd assumed that Pie, like per sister, had known my status but hadn't cared. That remark left me both stung and curious: was it mere carelessness, or had my own shocked reaction hurt per feelings, and this was a small payback? I never had time to find out.

At that moment, Kikito came into the hallway. She put one hand on my shoulder, one on the shoulder of the person to whom she was birth sister. As she kissed Pie on the cheek, Kikito's air-gills quivered slightly.

I'd always thought Kikito was beautiful; that night, she was splendid. She wore only makeup, body-sheen, a garter belt, and stockings—the last of which framed not only her beautiful ass but also a small, furry tail. In front, her pubic triangle was shaved and powdered, but clearly nonmorphed and female. When she drew close, I could tell she smelled like honey. At first I wondered if that, like Pie's scent, was the product of bioengineering; finally, I realized that the scent came from the powder. Edible, no doubt. More than ever, I wondered why she had invited me here. But I cared

less than ever, because I was completely ready for anything she might suggest.

"You wouldn't be stealing my invitee, would you now, sibling dear?" Kikito smiled at Pie and then, more reassuringly, at me.

"I told you we have the same taste in women," Pie said, to me but also clearly for per sister's benefit.

"Ummm." Kikito licked her lips. "Like that comedian on *The Now Show* said—'I like my lovers the way I like my Coff-E-Cream. Rich, sweet, and full-bodied with fat.'"

The latter two, maybe, I thought. I may have reacted visibly to the casual assumption that everyone there was "rich," but no one seemed to notice.

There was some tension between Kikito and Pie, obviously present but hard to figure out. It seemed like more than just a rivalry between co-sibs. Kikito looked at Pie at least as much, and as intensely, as she looked at me. Was it my imagination that Kikito's touch on Pie's shoulder was something other than sisterly? I wondered about Kikito's stance, and Pie's as well: close to each other but rigid, avoiding touch beyond the one contact point of Kikito's hand on Pie's shoulder, their breathing just a bit harder than usual. Overall, the effect was enough to make me wonder about Kikito's taste for round women—maybe, I thought, Pie's shape and Kikito's preference in lovers had more to do with each other than either sibling would admit.

"I think she's had a good time," Pie said to Kikito. "A good time, and a few—surprises. Wouldn't you say so?"

I swallowed hard and then nodded. "Very surprising, but very pleasant," I said, finally.

"Well," Kikito said to her sibling, "I'm sure you can find others to surprise." She looked Pie up and down and then turned to me.

"Let's walk," she said. "I'll get you a splash and a nibble, and then—" She patted my ass, swishing her own pert little tail as she did so. "And then, we'll get you out of those clothes—nice as they are—and introduce you to our hosts."

Kikito steered me to the refreshment stations, taking my arm in hers. The contrast was delicious: my arm pale, solid yet soft; hers brown and muscular. Her breasts swung as she walked. Their full weight, and the generous swell of her hips, complemented the athletic tautness of her limbs and abdomen. That was an unfashionable look, associated with time spent in selfish physical entertainment instead of helping others. But Kikito was the kind of person who didn't care what others thought, and I admired her independence. Anyway, I knew the stereotype was completely untrue in this case. Not only did she put in more hours at the med co-op than I did, Kikito was also known for her work in the animal wing of the bio-accidents depot, which she ran almost single-handedly.

Despite the release I had had earlier with Pie—and another at home, before I left—I found myself stimulated by Kikito's presence. She and I drew closer as we walked, until her breast brushed my arm with each step we took. The texture of her skin on mine made clear that her breast had been dusted with powder, too, and I found myself imagining the taste of it.

At first I took only brief glimpses of Kikito, glancing at her body and then back up to her face, when she spoke. Soon, however, it became clear that she didn't mind me looking. In fact, it seemed to please her that I wanted to. I especially liked the look of her thighs, lean but thick enough with muscle. When the light caught her pubic lips from the right angle, the taste-powder sparkled, more subtly but at least as brightly as my own edible glitter. I was clearly outclassed; but to my surprise, I didn't feel on the defensive. Her smile

was warm and reassuring. And I found myself imagining what it would be like to taste the honey-powder there, as well. "Pink-punch, tea, or pop?" Kikito asked when we reached the drink station. "Pink-punch is doused with E-rose," she said casually.

Once again, my shock must have shown on my face; Kikito giggled, then stifled it. Her brown eyes were warm, and I felt much more comfortable than I ever had with Pie. She knew I was an ex-urb, submanagerial rube. And it was no problem.

"No pink-punch, I guess," she said. "The E-rose is really goldplate on the lily anyway, what with the Hiyo and all. Still, a little arousal and empathy never hurt anyone, did it?"

My look must have told her that I wasn't so sure, but she smiled dazzlingly at me, anyway, as she poured some pink-punch for herself.

"Just tea for me. Assam, if you have it."

"Fine," she said, sipping her pink-punch and smiling even more stunningly. "But if that's the way you feel, I'd better take a shower before we go down with each other."

I didn't know which was more astounding, the casual offer of sex or the idea that her powder was doused with E-rose. On second thought, I wondered if it was an offer of sex or merely a suppositional statement. At least she acknowledged the possibility of sex between us. For now, I thought, that's enough for me.

Kikito finished her punch and set down the cup, which was quickly whisked away by someone with a bland, gender-free face and green hair down to the hem of per skirt. Again, I had to marvel of the ostentation. I knew it might be just for this party, but I was still astonished to see this many body-morphed servants. And when they were doing jobs that could have been done by a simple, single-command mech—well, even for the salary elite, that's showing off.

We walked past the nibbles and sweet-meats at the various food stations. I sipped my Assam, too distracted to eat anything. Kikito was usually a hearty eater, but I knew she wouldn't be consuming much tonight—not with the E-rose coursing through her system from within and without. She picked up a small form of marzipan and chewed at it thoughtfully.

"You know," she said, "we used to think that sex is the most basic human drive, but the Hiyo have shown us it's not."

I looked around, taking in the refreshment stations and the hallway beyond. In one corner of the room, two people were intertwined, forming a mound of multicolored feathers. I couldn't tell where one left off and the other began, and I wondered if they themselves knew. Closer to us, a gangly figure, over nine feet tall, bent down to stroke the back of someone morphed into a quadruped. In turn, she—the gender was very obvious from where I stood—was beckoning for a naked, rainbow-hued trio to leave the drink station and come join the fun. I thought about what I had just experienced with Pie. How right it had felt—not only natural but vitally important. And I knew, with an unshakable certainty, that at that very moment someone else was licking and sucking per skin, as I had been earlier. With or without gender, how could we do without sex?

Kikito studied my face, again reading my opinion there. I looked at her in return, feeling comfortable and un-ashamed. She set down the marzipan and continued in a slow, distant voice, overenunciating to keep her words from slurring.

"No, really. The drives for power and status are clearly more important. Think about it.

"What do people spend more time on? And how many people let their pay-work interfere with their sex lives? Do

you know even one person whose sex life is so primary that it jeopardizes per job?" I started to speak and then stopped myself. I could quibble with that example, but on the whole I felt Kikito was right.

Kikito's round, dark eyes were soft and dreamy; she was clearly skimming high on the E-rose. She grinned and brushed an imaginary crumb of marzipan from her breast. My eyes followed her hand intently, and I felt my pussy clench in a brief, involuntary spasm. Her gaze locked on mine, still dreamy, and she laughed.

"Oh, I'm not saying sex isn't important. And more for some humans than others." She laid her hand gently on my arm. "That's why we're here tonight, after all."

I set down my empty teacup and moved toward her, into her embrace. Some of her powder clung to my dress, and I knew it was time to disrobe.

"But sex is the basic drive of the Hiyo," Kikito continued. "They think of it as often as we think of money, acceptance, and power, all together. Their culture is based on it, as ours is based on domination of resources and each other. It's their security, their goal, their daily employment—" She held me close, looking intently at my face, yet focussed beyond it as well. The light shone through her dark, thick hair like a halo.

"You'll see," she said, and kissed me.

I had to agree with Kikito's point about which human drives were more basic. And yet—and yet— For all my worries, and all of the signs of status-upping I'd seen here tonight, the facts were that I still had been invited, that I was here, and that I was probably as accepted as I wanted to be. Certainly as much as I needed to be. Nonetheless, Kikito's words had made me feel even more thrilled—and anxious— about meeting the Hiyo.

At that moment, however, all fears were drowned as I enjoyed the full experience of Kikito's kiss. Unlike Pie,

Kikito's lips were cool, slippery with a fruity-tasting gloss: artificial, but made-up rather than engineered. Her mouth was as full as Pie's, though, and as inviting. We held each other when the kiss ended, as comfortable as though we had been partners for years.

"Let me get you ready," Kikito whispered to me, her mouth only inches away. Her breath was moist, tickling the depths and surfaces of my ear. Its brief, phantom caress stirred my pussy: still wet down there, I knew I was becoming wetter still.

Kikito began to undress me, as I had hoped and known she would. First she unfastened my duster, unhooking the collar and drawing her fingers down both sides of the new-zip. As its magnetic teeth unsealed and the duster parted, Kikito paused to take in the sight she had uncovered: the camisole, the glitter-gel, and all the lush fullness of my body underneath. The duster's skirt opened and fell away, and Kikito grinned appreciatively. She ran her fingers lightly over my jeweled thighs, above the stockings; but I knew she was really looking at the irregular, dark spot on my briefs, a clear sign of my arousal. Then she helped me take off the rest of my duster, licking above the top of my camisole as she slid the blouse over my shoulders. When we kissed again, I knew, I would taste the glitter-gel—and perhaps my own skin—on her mouth and tongue.

More than just pre-play to get me ready, the undressing was an act of sharing in itself. Skimming high on E-rose, Kikito was in turn playful, fierce, tender, and almost maudlin. She looked sad when she folded my duster and gave it to a waiting drone, but maybe that was just impatience at any delay. A moment later, she laughed gleefully as I pulled the camisole off over my head. And when she unsnapped my remaining underclothes, she clapped her hands like a little child. Soon I, like Kikito, had stripped down to a garter belt

and stockings. We stood facing each other, holding hands. Enjoying simply looking, and being looked at.

"Do you like-a my tail?" Kikito said, turning around. Looking over her shoulder, she wiggled and wagged at me. Her voice had a sing-song rhythm, but was deeper and stronger than her usual voice.

"Yes," I replied, amazed to realize I was speaking the truth. "The perfect complement to your perfect, squeezable ass."

In fact, the first glimpse of her tail had shocked me less than her air-gills do even now. Small, furry, and curly, it seemed somehow friendly, like the tail of a young puppy. Its movement was obviously under Kikito's conscious control, as well: kept still and limp to hide under her clothing, but marvelously expressive now that she was showing it off. One part of my mind noted how much extra the will-linked neurological work must have cost, but the rest of me cared much more about how it would respond to my touch and how it would feel in my hand.

"Talk about my ass!" Kikito faced me and reached out her arms. "I've wanted to feel that tuchus of yours since you first wore those red pantaloons to the co-op."

I flushed, realizing how oblivious I had been for so long, and how much her feelings meant to me now. My own feelings were as strong as the lust I had felt for Pie, but different—and, I sensed, far more important to both of us.

"Did you ever wonder if I'd been morphed?"

Kikito laughed and made a dismissive gesture: none of this mattered nearly as much as most people thought.

"No," she said. "Umm—your clothes made it clear—and the way you looked at me—"

I knew what she was saying, and what she was avoiding saying. It didn't pay to ignore the human drives, whether status or sex; but there was no reason to take them too

seriously, either. We were from different soc worlds, but in other ways we were made for each other. Only the future would tell which was more important.

"Could we go somewhere?" I asked. I could feel my heart beating more quickly. And I wanted Kikito to hold me close enough for her to feel it, too.

Kikito paused, her head cocked. She seemed to be listening for something, but I had no idea what. All I could hear was the mixture of voices and noises—chitter-chat and carnality—that had filled the room since we entered. Maybe she was hearing something from the E-rose, I thought, or maybe her hearing had been engineered to go along with the tail. Then I noticed the small bump, just under her hairline. Of course! More proof of what a rube I was, not to think that she might have had an innercom implanted. Even some people in my ex-urb were starting to get those.

"Later," she said, after a moment. Her voice was warm and inviting—a promise, not a put-off. She kissed me again, not as hard but even more passionately than before. Her mouth was still sweet with my glitter-gel; for one instant, I felt as if I were swimming in the taste, everything else in the world obliterated. I wondered if the E-rose in her taste-powder was affecting me through the skin. Then I wondered if the transport I felt was due to Kikito alone. Finally, I decided it didn't matter.

"Now, I think it's time for you to meet our hosts."

As we walked through the mazelike hallways, Kikito made sure I knew the protocol. We'd be met by a human, an office-appointed diplomat and keeper for the Hiyo. Per presence was nonnegotiable. After the introductions, however, the person would almost certainly leave me alone with the Hiyo, if I knew what I was doing.

"Alone?" I asked. I was slowly realizing that Kikito wouldn't be there with me, either. The thought was disappointing, yet also thrilling.

Kikito patted my arm. "You'll do fine."

When I was young, I'd had an uncle who was a researcher in history for the info-feeds. Not a very impressive position, but it was salaried. He wasn't around now: a few decades after I was born, he'd given up on age retardation. No one in the family could persuade him to change his mind, and finally he died. I certainly didn't understand it then, and I still don't. But I think it had something to do with his work with history, with the grasp it gave him of how things rise and fall and fade away.

That night, I thought of some of the research my uncle had told me about. The field was called "fairy tales," or maybe "folk tales." It was a literary genre, of a sort—stories people told each other, especially when they were pre-mature. They'd been very popular for a while, he said. I think it made him sad that they weren't anymore, although it was hard to tell.

Whenever I was home alone at night, he would dial me up and tell me some of the stories. At first I listened mostly because it pleased him, and he was a nice person—scary as he grew wrinkly and fragile, but nice. The stories seemed very simple, and I couldn't see that there was much to them. But over time, I discovered that they stayed with me, somehow, more than stories that had seemed much more interesting at the time. I would find myself thinking of little bits of the stories—a character, or event, or setting—at odd times throughout the day or night.

Long after my uncle was gone, I looked at the world around me and thought: we have become like those stories. The prince with the one swan wing. The talking audio-animo mirrors, or doors, or fountains. The fox-girl, cat-woman, or

goose-girl. And most of all, the poor, marginal match-girls and bell-boys, looking for the magic that will turn them into trans-urb royalty.

As we embraced and Kikito turned to leave me, I knew that I was about to face the highest royalty, the strangest magic. Soon, the hallway was empty except for me—although they had known not to stop us, I wondered how many of the body-morphed partiers we had passed were actually officials and guards. The door was heavy, like those in my uncle's stories. I think it may even have been real wood, though I hated to think how much that would have cost. I knocked, then heard a human voice answer from within.

I felt I had finally learned my lesson. No matter who answered, I was ready to use "per" mentally and avoid using any pronouns aloud, until I could check with Kikito. However, the person who opened the door was clearly male, in a way that left nothing to the imagination. He was morphed, his natural male genitals surrounded by ruffles of orange flesh, the purpose of which I could not begin to guess. By that point, though, I was ready to take that in stride. It shocked me only slightly more than his complete nakedness, which is to say not much.

In the next moment, I noticed something odd about his eyes. They looked natural, but their movement was not, tracking things in short, staccato jerks. Then the light hit them just right, and I saw a small glowing spot in each. Each spot was too small to be tapetum, though that had been my first guess, because the treatments had become so popular lately. Of course, I thought. He still had the old cyborg-style eye cams, instead of having switched over to full biological models like almost everyone else. I realized that had to mean he was old—decades older than I was, even older than the uncle I had just been thinking about. He looked just barely

post-mature, but that certainly meant nothing. Almost everyone did.

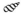

"Welcome," he said and held out his hand to me. It was tattooed with elaborate swirls and three interlocking rings.

"The sign of my office, given to me by these two Hiyo." As he was answering my unasked question, he pointed to a ridge that bisected his scalp and parted his spiky, red hair down the middle. I had assumed the ridge was decorative, but again I had been wrong. All the info-feeds had announced that telepathic innercoms were possible, but I hadn't been sure whether they were in use yet or not. Certainly, I'd never imagined I'd meet anyone with one. Yet another first for this evening, I thought.

"I'm Tapano Gan," he said. "Please, call me Tappi." His voice was friendly, bubblesome yet calm. In fact, despite the body-morphing and the outdated cyborg-cam eyes, his main effect was reassuring but enthusiastic—like a best friend's older brother taking you to a pub-den, protective but ready to let you in on all the fun. He offered to disable what he called "the human-specific channel" of his telepathic receiver, so that he could no longer read my thoughts. With an inner sigh of relief, I told him I would prefer that.

"The main purpose of the device is to interface with the Hiyo," Tappi told me. His tone of voice, when he mentioned interfacing with the Hiyo, was strongly laden with emotions I could not interpret. Pride? Protectiveness? Arousal? Surely something personal and important. I realized that whether or not he participated directly in what the Hiyo did with others, it affected him; that he would be a part of what I experienced this evening, no matter what.

"They've asked that you shed the rest of your clothing. They prefer all humans naked."

That explained Tappi's nudity, I realized, and even the Hiyo's choice of a tattooed symbol rather than a badge or vest patch. I also realized that he was in communication with them as we spoke—that the Hiyo were meeting me through his senses. Did they prefer his cyborg-cams to a more modern bio-fix? Did it give a picture more like their own senses? It was impossible to tell, or even guess.

Tappi helped me out of my stockings and garter belt. His touch was friendly and helpful, neither intimate nor coolly distant. He did have some trouble undoing one garter, in which the polarity of the Snap-It threads had become mis-aligned. He chuckled and then looked up at me, smiling; I met the clear gaze of his baby-blues, and I smiled too. I wasn't aroused by him yet, but I decided that I did like him. And that it would be very easy to desire him, in the right circumstances.

"Are you ready?" he asked, pointing to the door—short and wide, made out of shiny pink metal—at the other end of the room.

"As I'll ever be," I said. He smiled again and took my arm, escorting me to meet the Hiyo.

My first impression was the delicate smell that wafted out to meet me as Tappi opened the door. I've since talked to other people about their encounters with the Hiyo. Yes, the government discourages such talk, and supposedly it just isn't done. But like anything else associated with sex, people in the right situation will usually go ahead and do it anyway.

In these conversations, everyone I've talked to has men-tioned that odor, and no one can describe it. Elusive yet strong, not the odor of flowers or food but somehow similar to both—one person I talked to called it "the olfactory equivalent of breakfast in bed, waking up on Solstice morn-ing, and a hot bath. All in one." I can't do any better than that.

"May I introduce our hosts," Tappi said, gently pulling me forward by our linked elbows.

"Hiyo-ba—" he said, nodding to a frighteningly huge, elaborate, multilimbed creature filling one side of the room.

"—and Hiyo-ka," nodding to a smaller pile of flesh, dun-colored and amorphous, quivering in the middle of the other half of the room.

"They say they are very happy to meet you, and they wish you many fine orgasms this evening." Then Tappi switched from his official translator's voice and whispered, "It's okay. They wouldn't have picked you if you couldn't enjoy it. Go ahead."

The Hiyo had picked me? But I had no time to ponder that.

Even as Tappi spoke, I had felt all worry and anxiety leaving me. From small personal embarrassment to the deepest terror of the alien shapes, any fear was washed away within moments. Perhaps the odor from the Hiyo was chemically active, permeating and soothing my brain. Perhaps that change was the first foretaste of the deeper mental communion I had with them later. At the time, the effect was so deep that I didn't even wonder where or what it came from. I felt one stray bit of wonder and a hint of gratitude, and then nothing. I searched all the corners of my psyche and found only happiness. And the beginnings of sexual anticipation.

In describing the events that follow, I can't always tell you what information was told to me by Tappi and what came from my link with the Hiyo. For all I know, Tappi may have used his innercom again, to send me thoughts instead of reading them. This aspect of the Hiyo is hard to understand, yet vital: our minds, linked like the circles in Tappi's tattoo,

became one field of play, a shared erogenous zone at least as important as any flesh or skin.

Many humans say they know the erotic importance of thought, but only a few tantra-technicians even approach living that awareness the way the Hiyo do. We shared physical touch and we shared thoughts, and all of it was sex. In the Hiyo language, Tappi later told me, there wasn't any vocabulary to make that distinction clear. "Of course," he said, "they have a term for thoughts about sex. But it isn't used very often."

At Tappi's suggestion, I sat down within touching distance of Hiyo-ba. Upon first seeing the two Hiyo, I had been most intimidated by Hiyo-ba: not only per size, but the feelings the alien generated. And as I seated myself on the floor, I still felt that I'd be more comfortable with Hiyo-ka. Perhaps, I thought, that reluctance was why Tappi wanted me to approach Hiyo-ba first. Later, I decided that there could have been other reasons as well.

I had known that the aliens' sexes were referred to as "push" and "pull." Apparently, sex with pull was much more in demand among humans, but generally—for anyone short of, say, state regent—sex with push was required as part of the deal. Hiyo-ba was clearly the push member of this couple.

Still, I could not be afraid of Hiyo-ba. And the more I studied per, the more attracted to per I became. Unlike the featurelessness of Hiyo-ka's surface, Hiyo-ba was an intricate knotwork of protuberances: short and long, tentacles and segmented limbs, coils that ended in claws or probes, and delicate-seeming sensory fronds of all kinds. Beyond all these beautiful extensions, per skin was dark and opalescent, with highlights like the sheen of oil on water.

How could I stand not to touch such beauty? My hunger to feel per body was like ordinary sexual desire, and yet

unlike it. There was no pressure to hurry, but a complete assurance that nothing could ever be more wonderful than what I was about to do. Fired by enthusiasm for the Hiyo, my imagination was strong enough for me to feel phantom pressure on my fingers, even before I had reached out.

When I did make contact, I felt a spark shoot through my head, a ripping ecstasy like golden barbed wire in my mind. And in the next moment, that mind was no longer mine alone. I embraced Hiyo-ba totally and felt my entire being suffused by that sharp, golden electrical charge. A thrill rose from my painted toenails to my scalp, and beyond.

My pussy was wet, almost itching. I felt exhilarated and driven by unquenchable need. I didn't know if the excitement was mine or Hiyo-ba's, and it didn't matter. Later, as the link grew stronger, I could almost tell the difference: per sex, I decided, was stronger, harsher, more all-consuming. Later, I wondered if that was just an area of my own sexuality that Hiyo-ba had helped me experience for the first time. Probably it was both.

One of Hiyo-ba's grasping limbs—a beautiful spiral tentacle, mottled lavender and dark crimson—took my right hand and directed it to a stoma in per skin. The hole was oval, surrounded by slack, pale lips that were slightly sticky. As I gently stroked its delicate rim, the stoma closed, then opened again, exhaling a small gust of air. It felt good to my hand and smelled strongly of the delicate, lovely odor that permeated the room. Was the opening for breathing, eating, or excreting? Or something else, something I could never even imagine? I thought about the question at the time, but it would be hard to convey how little it meant to me. I felt our mutual need grow.

By that time Hiyo-ba's desire was in me, deep and hard—more than any flesh ever had been, or could be. I stroked the slick lips of per stoma and felt per desire swell

within. At one point I penetrated the opening, hooking my finger briefly inside. That seemed to be too much for Hiyo-ba, and I did not do it again.

Soon, I felt a shift, as clear yet as ephemeral as the awareness that precedes a partner's orgasm: yes, this is it, we're entering the next phase now. Hiyo-ba touched me with one hairy, segmented limb. It was a glancing touch, and yet I knew I had been hugged. The shining excitement I felt was joined by something more nurturing: a calm, like the rocking depths of the ocean. The touch was physically cold, like the skin of the stoma, and I shivered. But inside I felt a deep warmth join the scintillations and shocks.

Hiyo-ba's entire body trembled, a delicate wave from one end to the other. I felt myself being drawn to what seemed the center of per body: near the top, a bit off to one side. It was the only space bigger than my head that had no protuberances.

To reach it, I had to climb Hiyo-ba, actually ascending per like a small carnal hill. Each time I set my foot down at the root of one of per limbs and hoisted myself up by another, I felt our excitement grow. And with each part of per body I touched, my own responded differently. I was overheated and then more coolly relaxed, breathing hard and then gently. I felt arousal in every part of my body, sequentially: my breasts so heavy and nipples so hard they almost ached, then genital excitement so strong that I felt my own juices running down my leg. Even my fingers and toes clenched and unclenched; even my scalp flushed and tingled.

By the time I reached the top, my entire body hummed with lust. It seemed that our excitement must fill the whole room: I thought briefly of Tappi, but couldn't bring myself to look in his direction. I felt Hiyo-ba in each monad of my consciousness. I was displaced, or transformed. Hiyo-ba's

pleasure filled the universe, so how could I have been anything other?

The climb was strenuous, and by the time I reached Hiyo-ba's finishing-spot I was breathless from exertion as well as from sex. But I could no more have paused for breath than I could pause for breath during orgasm. Not that this was our orgasm, yet. I shivered at the knowledge of how much more intensity I was to experience.

Hiyo-ba did not have to guide my hand; by that time, per wishes were mine, on what seemed like a cellular level. I put my hand flat on per ultimate sensory zone and felt another explosion of delight and yearning. I could also feel the beginning quakes of my own physical orgasm, though that was much less important. Per skin was smooth and tender; I felt it not only under my hand, but up through my arm and into my heart. Suddenly, I could hear every sound in the room, from my own breathing to a rustle of Hiyo-ba's limbs in Tappi's direction. Each sound was like a caress on my skin, but also phantom through all of my flesh and beyond. I knew Hiyo-ba's physical release had begun, and I had to hurry.

I rubbed my relaxed hand, fully open, back and forth across Hiyo-ba. Our delight rose and climaxed, and we finished together.

For a moment, I felt like a child's inflatable toy that has been overfilled but cannot explode. Every speck of my tissue, every thought of my mind, was filled. I felt the universe turn red; I felt as though I were immersed in lead, slowly dispersing in a molten sea. I was infinite and powerful, yet with a dull, dark current. This pulsed through me in waves, each cresting just when I couldn't stand it anymore, yet wanted it to go on forever. My being rose and fell, a small silver cord like a tightrope through the abyss of energy that we had created together. Later, I wished I'd let go of even that.

My first awareness afterward was of a pressure in my head, just below a headache. My second feeling was sadness that I was again forced into the limitations of my individual self. I felt frenzied and elated, sleepy yet charged with energy. Moreover, although Hiyo-ba and I had clearly finished together, I felt charged rather than relaxed. The climax, powerful as it was, had come just short of release for me, as though one state of tension had been substituted for another.

Hiyo-ba, however, was obviously exhausted. Per skin grew cool under my hand. There was another shiver through per body, this one leaving a sense of satisfaction and quiet in its wake. As I climbed back down, I felt a series of affectionate farewells, like hugs or kisses from the inside out. I began to feel more stable, no longer in danger of bursting from the energies inside me. When I passed it, I stroked the stoma that Hiyo-ba had directed me to before. I felt a small, happy hiccup as I did—a last giggle of joy in our shared being-space, before we parted. I noticed I had a good taste in the back of my mouth, that my vision was sharper than it had been, and that my own skin smelled like the Hiyo-smell.

Tappi rose as I approached him. His flesh, like mine, was flushed and wet. I noticed that I had lost most of my glitter-gel, but we both shone with perspiration. I'm sure that he had enjoyed a sexual experience as well; but what kind, I don't know and wouldn't guess. Still, through the afterglow in the room, we came together intimately, like old lovers. Holding me, he stroked my arms as though he were discovering a new continent. As though he were holding human flesh for the first time.

"We chose well," I heard both through my ears and in my mind. The effect was harmonic, rather than confusing: counterpoint within one muse-box. I realized that Tappi's union with the Hiyo ran even deeper than what I'd experienced, or

at least was more permanent. In fact, I wondered if, despite his genitals, Tappi was really a human male any longer. Or totally human at all. Could a person be spirit-morphed, human in shape but essentially alien in being?

I've often said that the strangeness of the Hiyo didn't matter. In this case, Tappi's alienness did matter. It made him even more desirable to me. I felt sympathy with his familiar humanity and a desire to encompass his otherness. I have to admit that I had similar feelings, though weaker, with men in the past—separated as we were, in those cases, by the gulf of gender. I think part of me would always want to meet that otherness and get to know it, finding the strangeness within myself and the common ground I shared with the aliens. Maybe that's part of why I was invited to share sex with the Hiyo that evening, although I'll never know for sure.

Tappi held me, and before I knew it we were kissing. He certainly felt like a natural male: I could feel the light scratch of his beard stubble against my cheek. His kiss was more forceful than Kikito's and less varied than Pie's, but still attentive and responsive. I felt his morphed ruffles of tissue brush against me, tickling me below my navel but above the pubic hair. Soon, I felt his natural equipment stir as well.

"Ready for Hiyo-ka now?"

It was not really a question, but my face-wide smile was correctly taken as an answer.

From the very beginning, my experience with Hiyo-ka was less awesome, but every bit as wonderful. Per mate was aggressive, filling; Hiyo-ka was enveloping and soft, though every bit as strong and exquisite.

I approached Hiyo-ka quickly. Before I was arm-length from per, the alien was pulling me toward per mentally and reaching out for me physically. Yet it was one motion, into a shared being-space. I felt stirred up inside, like the one time I'd tried popping whiz but without the jangly edge. I felt like

an ice skater, following my own gliding path up into the stars. But Hiyo-ka was my goal and path, both.

Hiyo-ka's amorphous body, I found, concealed an array of possibilities even more wonderful and varied than Hiyo-ba's. Per pseudopods could appear and disappear magically, flexing their luxurious, thick bulk and then smoothing back into Hiyo-ka's strong, rippling curves. No part of per was ever stationary, or even the same from one moment to another. The kaleidoscopic dance of per extensions was entrancing, transporting.

And I was in the middle of it. I needed to hold Hiyo-ka close, to feel per skin against every possible inch of mine. I knew that Hiyo-ka was glad: glad that I was happy, glad that I felt such skin-delight, glad that I had such a generous expanse of skin to feel delight in. I experienced a hint of my own body as Hiyo-ka perceived it: too limited in both size and ability, but also warm and giving like per own.

In the best of human sex, I think, the partners are so close to unified that only a split second interposes itself between desire and fulfillment. Just a moment between the aching clitoris and the answering tongue; just a thought that some other touch might be better, before the change. With Hiyo-ka, there was no delay. In fact, there was no space between us, no gap to allow for the possibility of a delay. It was impossible to tell my wish from per action, my need from per response.

And so per extensions penetrated my every orifice, finding and answering my need within. Always just deep enough, just thick enough, just hard enough— I began to orgasm and did not stop. I sucked on Hiyo-ka, feeling my ass and pussy clench in alternate waves of ecstasy, bearing down harder and harder on Hiyo-ka's adaptable, intoxicating organs. Per touch was careful yet strong, probing and satisfying me. I felt per on my breasts and around my thighs, stroking my neck

and lightly brushing my clitoris, stroking the shell of my ear and oozing between my toes. Hiyo-ka responded to longings I never knew I had, and it was per joy to do so.

Soon, I could no longer keep my eyes open. Stimulated throughout my skin and full in every orifice, I drifted in our tender, welcoming space. It felt comforting, yet mysteriously exciting. Like being tucked in between clean sheets, or a clear blue sky on the first day of summer vacation; like a familiar tune when you're in a foreign country. Hugged in our mutual being, I flew free. It was refreshing and happy-making, thrilling and ice silver. Per presence was everything to me, yet nothing in itself. We made the gate and walked through it, simultaneously. And my orgasms continued to explode in and through me, shaking every corner of our being.

Hiyo-ka was receptive, yet somehow demanding. As the orgasms coursed through me more and more strongly, I felt my being widening, diffusing through the room. Hiyo-ka's merriment penetrated me, asking for more.

I sensed Hiyo-ka's satisfaction, as I had sensed Hiyo-ba's, but Hiyo-ka's was even more alien. Per nature was to respond to mine; it was like dancing with the figure in a mirror. Yet—completing the cycle—there was no separation between my orgasm and per bliss. It was not a cycle of my sexual responses stoking Hiyo-ka's inner fire, but rather a unity of shared delight. I don't know if Hiyo-ka felt anything that did not come from me. But the alien created fields of infinite potentiality, and I felt the exquisite necessity of expanding to fill and fulfill per.

Toward the end, I had lost all awareness of my body. Ultimately, it was too poor a conduit for everything a sex partner of the Hiyo thought and felt. With Hiyo-ka, however, my being didn't even try to contain itself, but stresslessly slipped beyond my physical self. I felt like a king, floating

amid lush purple robes; like a goddess, sailing across the blue sky, holding the sun in the palm of my hand.

I do not know what happened when we actually finished. For a moment, my being penetrated everything, but could hold nothing—not even awareness of itself. In that moment I knew why sex with a pull-Hiyo was more desirable than anything on earth; but it was an awareness I could not bring back with me.

When I returned to consciousness, Hiyo-ka was shuddering. Deep, world-shaking quakes ran through per, not surface trembling like Hiyo-ba but flesh waves, strong and solid, a meter high from crest to trough. I couldn't tell if Hiyo-ka was still finishing, or if this was an after-effect. Tappi was stroking Hiyo-ka's skin and singing in a low, soft voice. It sounded like a lullaby, though it could have been a love song; I couldn't make out the words, if there were words. I was standing a meter or more away from Tappi and Hiyo-ka, completely unaware of how I had gotten there. Though teleportation had been proven impossible decades ago, I wouldn't have been surprised if Tappi had told me I'd disappeared from one place and reappeared in the other.

I felt refreshed, renewed from the inside out. Full of energy yet balanced and light, I was aware of every inch of my body, and the awareness was exquisite. I examined my flesh, half surprised it didn't glow with life.

"Is this—sex?" I asked.

Tappi looked up, his eyes still hazy with love. In any other condition, I would have felt jealousy: I'm vacationing, I realized, and he lives there. As it was, I felt further connected to him by that insight. And sad, although I didn't know why at the time.

"As close as we come to it."

Then he stood and walked toward me. He took his hand from Hiyo-ka only at the very last minute, stroking per almost

wistfully as he did. Per body shuddered one last time and then rolled over, toward the corner and away from us. I wondered if Hiyo-ka was in postcoital sleep. Or whether the Hiyo slept at all.

"Or maybe it's something else," he continued. "Something bigger, with sex only one part. Even Hiyo sex.

"My mother was a holy-rollie, and after my first time with the Hiyo, I thought—that was what she'd been talking about. But I dunno. It didn't seem sexual for her."

"Your mother was a holy-rollie?" I chuckled, feeling the laughter in the muscles of my chest, in my throat and tongue and lips. It was exotic to speak with actual words. How odd and delicious, I thought, to be a mere human!

Tappi laughed too.

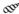

"The Hiyo choose the strangest people, but no one they choose has ever turned them down."

This time, I did feel a pang of something like jealousy, though it was more like regret. How could I ever go back to human sex after that? And Tappi had it all the time, I thought. A combination of strangeness and sharing that body-morphers could only dream of achieving, no matter how many surgeries they had.

Then I realized that Tappi was crying. His eyes shuttled quickly from one side to the other; as he slowly batted his eyelids, fat tears streaked down his cheeks. He didn't cry as people usually do, and it was not just because of the cyborg-cams. But he was crying.

"I heard you earlier, you know." The tone of his voice, saying the word "heard," made clear that the process hadn't necessarily involved sound.

"I think I am soul-morphed. And I don't know whether I'm glad or not."

I held him tightly, patting his back and then smoothing his spiky red hair back over the ridge bisecting his scalp. At first there was nothing sexual in it, just one human being reaching out to comfort another.

But Tappi and I had just been through intense sex together, although we had never touched. Neither friends nor lovers, we were somehow both, and more. He cried and I held him, feeling his emotions with the limited, vulnerable empathy that is all we humans have. Did he really feel what I imagined he did? I realized that we'd never really know, but that this was good enough. In fact, that desperate guessing seemed somehow more wonderful than any alien certainty.

Soon he looked at me and grinned, one tear nudged off his cheek by the smile. I caught his tear as it fell and brought my salty finger up to his lips, for him to kiss. He continued to cry for a moment, his grin behind the tears like the sun shining through an afternoon shower. I kissed his nose.

"You're human," I said. "You don't lose what you have because you get more." As I said it, I realized how right that was. And how much it applied to me as well. "Of course you're different. Who isn't?"

Tappi kissed my nose, and then my mouth. Our arms were wrapped around each other; I pressed my body to his more tightly. He grabbed my ass in his broad hands, pulling me even closer. I still felt that profound awareness of my own body, and now it extended to my awareness of him. I felt him gently sigh into my chest as he bent to kiss my breasts. His groin brushed my leg, and I felt his flesh stir against me.

Suddenly, I realized that his penis had not been erect at any time during the Hiyo-sex. Only with me. I'm sure he'd had orgasms, as I had. But it had not been human sex, and he had not been excited in ordinary human ways. I wondered how long it had been— Every joy was unique, I realized. Nothing was a substitute for anything else.

As he sucked my nipple, Tappi reached his hand up and into my pussy, delicately probing between my engorged labia. He smiled when his fingers entered wet heat. I could see that he was ready, too: his cock stood up proudly, the head blushing a deep red. His morphed ruffles were also swollen, especially between his genitals and navel. They were thicker and had darkened to a rich pumpkin color.

"You're so beautiful!" he cried. I could hear his fingers pumping in and out of my vagina, a slobbery sound that made me even hotter. Why not? In that moment, I accepted my own sex in a way I never had before, revelling in its clumsy, natural, wet humanity.

I sank to my knees, eye-level with his cock. His balls hung down loosely, and I cupped them in my hands. I licked the scrotum, enjoying the contrast between the silky skin and wiry copper curls. He clasped his hands tightly to my shoulders and moaned, tipping his pelvis forward and bracing his legs. I stroked him, happy to feel the twin nodules of vas-valve surgery. And amused that this was the first time I'd had to think of contraception all evening.

Careful not to bring him to orgasm, I licked and sucked his cock and balls. First I sucked the glans alone, then I took his shaft deep into my throat. As he drew back, I massaged his dick with my firm, rounded lips, laving the glans with broad strokes of my tongue. He began to thrust in and out of my mouth, though gently and with firm control. When he pulled the shaft out, I was delighted by how it gleamed, wet with my saliva. I felt my own excitement rise with his, and I thought about the difference between that and the psychic interpenetration I had just experienced. About how our skin separated, yet joined us. As I licked his scrotum again, one delicate pearl of juice rose to the tip of his penis. I caught it as it fell and stood up to offer it to him: a lascivious echo of his earlier tear.

"I want you in me now," I said. He smiled and led me to a couch flanking the pink metal door we had entered through. I glanced at the Hiyo, who seemed silent and unmoving.

I knelt on the couch, my torso braced against the back and my broad ass pointed invitingly toward Tappi. In one instant I felt his hands on my hips—in the next, his prick probing against my labia— And then he was in. I bucked back against him. He stroked forward even more forcefully.

I wish I could have told him how wonderful it was. More than ever, I felt both separated and joined by our flesh. His thick prick was a welcome presence, filling me inside but leaving my deeper being whole and untouched, as the Hiyo had not. Yet the greater awareness of a separate self, I realized, also meant having more to voluntarily share.

The sex was warm, funny, companionable. I felt as though we were truly partners, in every important sense. He tweaked my nipples, and we both laughed. His pelvis slapped firmly against my round, lush ass; I imagined I could feel his rough, red pelt rubbing my pale skin. His morphed skin teased my labia and caressed my hind-cheeks. I shook my ass from side to side and he moaned appreciatively.

I leaned back further, bracing myself between Tappi and the couch, the fabric rough on my flushed skin. As my own heat took me from inside, all I could do was whimper. The tempo of my sounds matched his thrusts, speeding up as they did. Joy pulsed through me, screaming for release.

We finished together. Just as my tension broke into orgasm, I heard him yell and felt his pulsing gush. I felt the sheath of my vagina flex and grasp, milking his cock deep within me. Before I had stopped, he was leaning forward, peppering my neck and back with spontaneous, happy smooches. It was a few moments before we both could stand.

By that time, I had become fully aware of something I'd not quite noticed before: the Hiyo-smell was rising in the room, already overpowering and growing even stronger. Tappi looked over his shoulder at the still-quiet forms, then back at me.

"I think it's time for the next introduction."

I wondered if they Hiyo had just finished their equivalent of a refractory period, or if the sex between Tappi and me had awakened them. Later, it occurred to me that they might have allowed us our time together, then decided we'd had enough.

Tappi escorted me through the pink metal door and to the wooden one, hugging and patting me and smiling reassuringly. I didn't know if I'd ever see him again, although I knew we'd be friends and lovers if it did happen. I had shared with him through the Hiyo and as a human, skin-to-skin. In each case, he'd given me something that I hadn't had before. We'd touched each other in pleasure, and in the heart.

As he ushered me through the door, he thanked me. Uncertain what to say, I hugged him again, then kissed him goodbye. As he closed the door behind me, I saw that he was crying again.

Before I could turn around, I felt a pair of slender, strong arms grabbing me from behind and heard Kikito's voice.

"So what's doing, kitty-pet? Didn't you love it?"

She, too, was now totally naked, except for a glowing pink party Streem-R draped over her tail. Her tail wagged, and the plastic strip waved back and forth in the breeze. Her hair was damp, and her skin shone. I wondered what she'd been up to. But my guess was that I'd find out.

I gazed at her dark, happy face, trying to figure our how I could ever put my feelings into words. After a moment I gave up, and we just hugged and kissed.

None of the Above

Kikito started down the hallway, tugging at my hand to pull me along. She moved quickly, bouncing on the balls of her feet, taking long strides; I ran to keep up with her.

"The party's winding down," she called back to me, "but I'm sure I can find you something to eat. And someone to eat it off of." Her eyes no longer had the telltale dreaminess of E-rose, but there was magic in them nonetheless.

"Don't worry. All the sweet-powder is long gone by now. There was this guy with a morphed tongue, see —"

I put on a burst of speed and caught up with Kikito. When I plucked the Streem-R from her tail, I discovered the fur was even softer than I had imagined.

By the time Kikito and I walked hand-in-hand to the front door, only a few people were left in the front rooms and hallways. One person, body-morphed with scaly armor, was asleep in the foyer, curled up like a pangolin or armadillo. Five, who appeared to be naturals, slept together in the main hall, in one comfortable, indeterminate pile. By the refreshment stations, two people licked pink-punch from each other's breasts; I couldn't be sure what gender they were, though all five breasts involved were twice the size of mine. Pie was nowhere to be seen, but of course the house had many rooms I hadn't been in. No doubt she was somewhere enjoying herself.

I accepted my clothes from the same body-morph who had greeted me—now exhausted, fur matted and scales sticky with pink-punch. Apparently others had explored the spikes visible through his briefs, though I hadn't had time to. Well, maybe next time, I thought.

It felt odd to be dressed again. Like that princess in my uncle's stories, putting on her finery at the stroke of mid-

night. But instead of a coach pulled by six white thunder-birds, I'd be taken home by limousine. The same limo that Kikito had promised to send for me in a week. She'd apologetically explained that she wouldn't have another party until next month, but— I'd hugged her and honestly said I'd be even more glad to have her alone.

As we kissed good night, Kikito fastened something to the collar of my duster. She'd taken it from a basket by the front door, which I'd noticed as I came in: it was filled with message badges that said, "NONE OF THE ABOVE." At the time, I'd dismissed it as more politi-prop from the Committee to Un-elect the President. Thinking about it again, I wasn't so sure. About the same time that option was added to the ballot, it had to be added to the census question about gender, as well. Perhaps a finite range of choices would always be too limiting. Even for us naturals.

"Remember, kitty-pet," Kikito whispered in my ear, "no one else could be like you, no matter how much they tried. Don't think you have to change." She kissed my cheek. "Or stay the same."

Of course I'm different, I thought. Who isn't?

I was already looking forward to next week.

About the Contributors

Katya Andreevna's erotic fiction has appeared in *Heatwave: Women in Love and Lust, Power Tools, Once upon a Time: Erotic Fairy Tales for Women,* and *Best American Erotica 1996.* When she is not writing, she practices yoga as a way of staying in touch with the Goddess.

Primarily trained in criticism/scholarship and teaching, **Bernadette Lynn Bosky** writes mostly nonfiction on topics from Stephen King to Rosicrucianism. She lives a deceptively placid life in the 'burbs of NYC, with Kevin Maroney and Arthur Hlavaty. All three are active in sf fandom. After "None of the Above" appeared in the first Circlet Press volume of *Worlds of Women* in 1993, it was chosen by Susie Bright for inclusion in the 1994 *Best American Erotica.*

Renee M. Charles lives in a houseful of cats, has a B.S. in English and also teaches writing. She draws her influence from genre masters such as Ray Bradbury, Theodore Sturgeon and Dean Koontz. She has published over 100 stories and poems in magazines and anthologies such as *Weird Tales, Twilight Zone,* and *2AM.* She has previously contributed to the Circlet Press anthologies *Blood Kiss, Genderflex, Selling Venus,* and *Fetish Fantastic.*

Shawn Dell is an artist and writer who lives in New York City, but is occasionally spotted touring the country on her motorcycle "Medusa" looking for adventure and material. Her work has been published in *Detour* magazine, *Girlfriends* magazine, *Penthouse Variations,* and *Bad Attitude.* She is also included in

the Cleis Press lesbian vampire anthology *Dark Angels,* edited by Pam Keesey.

Alayne Gelfand lives in the California high desert overlooking Palm Springs, where she makes wind chimes and hand-painted lamp shades to sell with her two partners at craft shows and street fairs. Painting is her main love in life, but she has found herself writing poetry and fiction since she was ten, driven by some inexplicable, unknown, unstoppable force. Her poetry has appeared in the small press and in a dozen chapbooks. This is her first sale of fiction. She has edited the annual erotic vampire anthology *Prisoners of the Night* for the past twelve years and hopes to continue to do so for another twelve.

Beverly Heinze lives in the Santa Cruz mountains, where, earthquakes notwithstanding, she enjoys writing science fiction stories. She has worked as a research biologist in genetics and radiobiology (six years with NASA), a teacher, and a group psychotherapist. She loves writing science fiction because it allows her to use her imagination and get away with it.

Linda Hooper grew up in Central California and moved to Santa Cruz to meet lesbians as soon as she could. She writes stories and essays, and produces lesbian and gay cultural events. This story is the beginning of a longer work on a feminist messiah. Other erotic fiction of hers has appeared in the Circlet Press publications *SexMagick* and *The Beast Within.* Her story "PG Diary" was included in *Best American Erotica 1994.*

Raven Kaldera just can't seem to stop writing erotic science fiction. Her work has appeared in the Circlet Press anthologies *S/M Futures, S/M Pasts, SexMagick II, Blood Kiss, Erotica Vampirica,* and *Genderflex.* She lives in the Boston area with her wife and daughter.

Judy T. Silver has been writing for several years. Her short stories have appeared in the small press and include science fiction, fantasy, and horror. She lives outside Boston with her

partner, her son, two iguanas, and eight show rats. She is currently writing a science fiction S/M novel.

Cecilia Tan, editor, has edited close to twenty anthologies of erotic science fiction for Circlet Press on themes like erotic technology, elves in bondage, and gender bending, as well as *SM Visions: The Best of Circlet Press* (Masquerade Books, 1995). Her erotic fiction has appeared in magazines from *Penthouse* to *Ms.* and in dozens of anthologies including *Dark Angels: Lesbian Vampire Stories* (Cleis, 1995) and *Herotica 4* (NAL/Plume, 1996). Her story "Pearl Diver" is included in *Best American Erotica 1996* (Simon & Schuster, 1996).

Kitty Tsui is the author of *Breathless* (Firebrand Books, 1996). Her poems, short stories, essays, and erotica have been included in over forty-five anthologies worldwide. Formerly from San Francisco, she lives in the heart of the Heartland with her vizsla Meggie Too. She just completed a historical novel, *Bak Sze, White Snake*.

Jessy Luanni Wolf says, "I've lived a hard life and probably carry the scars, but I hide them fairly well. I am a mother, a writer, a lesbian, a teacher, a student, a friend, a lover, a political liberal, and I can use a computer. I am a fairly spiritual pagan. I believe in reincarnation because I think we all need and deserve a second chance. I am 47 years old. I've published in a few anthologies and small publications under my name and also under the names Jessie Lynda Lasnover and Jessy Luanni Blackburn. Some other women and I recently began publishing *Coffy Time Blues,* a feminist literary quarterly. I have vivid dreams and an occasional vision. Maybe I am a little bit crazy, but then, who isn't?"